History of Art

LEARNING
SUPPORT
SERVICES

KT-471-587

stamped below

City College
NORWICH

2 2 OCT 2004

0 7 JAN 2005

1 4 JUN 2005

2 8 SEP 2005

1 9 OCT 2005

- 9 NOV 2005

2 0 APR 2007

3 1 OCT 2007

- 7 APR 2008

2 8 APR 2008

History of Art

A Students' Handbook

Fourth edition

Marcia Pointon

(with the assistance of Lucy Peltz)

Routledge
Taylor & Francis Group

LONDON AND NEW YORK

First published 1980 by Allen & Unwin (Publishers) Ltd

Second edition 1986

Reprinted in 1992
by Routledge

Third edition published in 1994

Reprinted 1994, 1996

Fourth edition published in 1997
by Routledge
11 New Fetter Lane, London EC4P 4EE

Simultaneously published in the USA and Canada
by Routledge
29 West 35th Street, New York, NY 10001

Reprinted 1998, 2000, 2004

Routledge is an imprint of the Taylor & Francis Group

© 1980, 1986, 1994, 1997 Marcia Pointon

Typeset in Times by Florencetype Ltd, Stoodleigh, Devon
Printed and bound in Great Britain by
Biddles Ltd, Guildford and King's Lynn

British Library Cataloguing in Publication Data
A catalogue record for this book is available from the British Library

Library of Congress Cataloguing in Publication Data
A catalogue record for this book is available from the Library of Congress

ISBN 0–415–15181–3

For Thomas and Emily

Contents

Figures

Preface to the fourth edition

This handbook is intended for students, of all ages, contemplating studying History of Art, or in the early stages of their careers as art historians whether in the sixth form (or equivalent) or at university. Originally published as a modest project in 1980, its strengths, I believe, have always lain in its combination of intellectual map and compendium of practical hints. I like to think of it as a kind of Rough Guide to the challenging, exciting and supremely rewarding complex of academic pursuits known as Art History. I have retained the original title, as it corresponds to what is familiar in schools, and the format which has seemed to work well for my readers. Art historical studies have expanded and strengthened in the English-speaking world since 1980 and, as we approach the millenium, it is interesting to look back and recognise the growth to maturity of this discipline, and the major part played in this process by scholars in this country. This book cannot survey that development but, without it, it would not exist. The decision to revise the 1994 edition stems from the knowledge that areas of scholarly study evolve (though possibly not to the extent that we like to think) and the conviction that for this book to be useful it must be contemporary in its explication and accurate in its information. Readers familiar with the previous edition will, therefore, find some sections amplified and, most significantly, more direct guidance on choice of degree course (in Chapter 3), on careers, on study skills and how to read, and a discussion of electronic forms of information retrieval (in Chapter 5). The index has been much improved so that it will now be possible to search under subject headings. I am grateful to the many students, friends and colleagues whose comments have been stored up and have influenced my revisions. I am especially grateful to David Phillips for his advice on information systems and to Rebecca Barden for her support. The revisions for this edition would not have been

possible without the stalwart help of Lucy Peltz who has been energetic and inspired both in her scrutiny of the text and in her searches for material. Working with her made a real pleasure of what might, under other circumstances, have been a chore.

Manchester 1997

1 Engaging with art

Those of us who live in Western-style societies inhabit a world of visual communications: television, films, videos, advertisements, traffic signs, signals in both urban and rural environments warning and alerting us, graffiti on buildings and vehicles, photographs in newspapers, paintings in galleries, serial strips and cartoons, the packaging on consumer goods. None of these forms of communication is outside history; all are determined by how we live and interact with our environment now, as well as by what happened in the past. Visual culture spans a vast range of experience, therefore, from the label on a pair of tights to a Rembrandt self-portrait in the National Gallery. Art History is concerned with exploring and measuring the effects of these experiences, with analysing them in order to understand how they are composed and constructed, and with recognizing how they 'work'. In other words, what makes artefacts that are experienced visually communicate certain things at certain times to different groups of people in varying ways?

Art History is not concerned exclusively – or even primarily – with what is often popularly understood as Art, with a capital *A*. That is to say that it does not only address 'high' culture and its objects. Record sleeves as well as Rodchenko are the business of the art historian, who is, moreover, not only interested in objects but also in processes. To put this in a more recognizable historical framework, art historians concern themselves with visual communication whatever its intended audiences or consumers. Thus sixteenth-century German woodcuts (Figure 1) that probably cost less than the price of a plate of herrings at the time they were produced are of equal (though different) interest to, for example, the painting now known as *The Mona Lisa* which is fixed to the wall of a gallery in the Louvre Museum, Paris, behind layers of protective glass. Accordingly the Gallery of Ornament in the Victoria and Albert Museum, London,

Figure 1 Anon., *Battle for the Trousers*, woodcut frontispiece to Hans Sach's play *The Evil Smoke*, Stadtgeschichtliche Museen, Nuremburg

displays mass-produced trainers (notable for their non-functional ornamentation) alongside examples of fine pre-twentieth-century ceramics (Figure 2).

Because Art History, as an area of scholarship and learning, exists in a relationship with other professions, like those concerned with the display and sale of artworks (whether contemporary or historical) and those concerned with publishing and marketing attractive picture books, the practice of art historians is often misrepresented and

Figure 2 Trainers on display outside a sports shop. Photo: author

misunderstood. Art History remains, at some level, the history of works of art and how they were made; the perceived gap between what artists do and the matters that preoccupy art historians has not infrequently been a source of amusement (Figure 3). But Art History is not only about artists and their works, it also takes (or should take) responsibility for trying to understand how and why the work of some producers gets discussed while the work of others does not, and why artists and their work signify, or produce meanings for people, in certain ways at certain periods in certain places. Art History addresses not only how a work by Leonardo came to be made and how it was received at the time it was produced by why we think of Leonardo as Art and an advertisement in a magazine as Not Art.

It is this very quality of 'Not Art' that has been exploited by so-called billboard artists like Barbara Kruger, who offers us what we are conditioned to expect to see but subverts this to make us see it in a new way, thus drawing attention to the political dimension of apparently apolitical acts of communication (Figure 4). Moreover, Art History also takes on board the aspects of image-making that a Leonardo and an advertisement might have in common (the use of the female human figure, for example). By considering those aspects across historical periods, insights may be offered that contribute to our historical knowledge. So the shelves of art books on individual

Figure 3 Cartoon from the *Guardian*, 12 June 1992

artists which still predominate in bookshops from New York to Tokyo and from London to Helsinki, or the kinds of art reviews that appear in, for example, the London *Evening Standard*, do not at all indicate what Art History these days is about.

Having said that, it remains the case that much that is taught at undergraduate level in universities and colleges focuses on, or at least is based on, the traditional trio of painting, sculpture and architecture. People who enjoy paintings are sometimes reluctant to analyse them for fear of spoiling the richness and spontaneity of their experience. It has been suggested that some of the work done by sociologists or social historians of art, or by those whose concern is with theory rather than practice, ignores and indeed denies the aesthetic experience, the fundamental pleasure of looking as well as the very special act of artistic creativity. This view is a bit like the notion that knowing the ingredients of the recipe, recognizing the method of cooking and seeing the utensils employed detracts from the taste of the dish. But Art History does more than this; it seeks to explain why (to pursue the metaphor) certain foods are favoured in certain cultures: what the differences in cultural meaning are between, say, fast food eaten from a disposable carton, a picnic hamper prepared by Fortnum and Mason, or a cassoulet made according to a recipe by Elizabeth David and cooked in a Le Creuset cast-iron casserole.

Acknowledging the importance of enjoying something does not, of course, preclude a historical analysis of the object that is arousing pleasure. It might in fact be more pleasurable if we know more about the object we are viewing. Moreover, pleasure is not a simple matter.

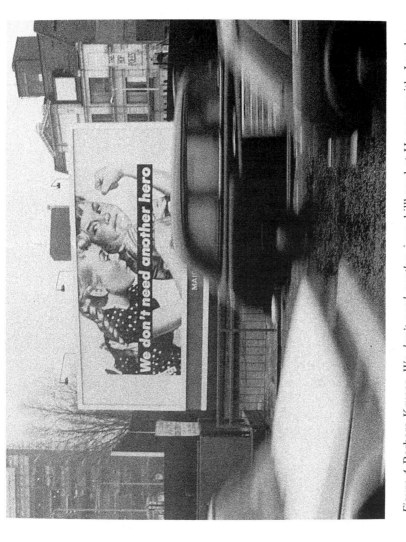

Figure 4 Barbara Kruger, *We don't need another hero*, billboard at Hammersmith, London.
Photo: Geoff Dunlop

The arousal of our senses – and how we recognize and register it – is itself open to interrogation. It is also historically located. Why we like particular characteristics of certain sorts of objects at any one time is not simply the result of our genes or our own particular personalities but is determined by values promoted within the society of which we are a part. So, while no one seeks to underestimate the importance of sensuous and instinctual responses to art objects, the notion that the sensuous is undermined by the intellectual is a legacy from a period in the past which promoted art as an alternative to thought.

In fact we unknowingly engage all the time in forms of visual analysis that are not dissimilar to certain kinds of art-historical activity. Whenever we deliberately and consciously choose a style that we know to be of the past (a William Morris type fabric, a 1930s-style tea cup, or a 1950s tie) we are applying aesthetic and historical as well as functional criteria. We are motivated by an awareness of the symbolic as well as the utilitarian: a sports bag with a brand name emblazoned on it, a pine bath-rail instead of a stainless steel one, a purple Citroën Dyane instead of a white Volkswagen Golf. Each time we stand any length of time before a painting and find ourselves stimulated and provoked to think, to ask questions, we are engaged in criticism. Every time we look at a painting and then, moving to look at the one which is hanging adjacent to it, find ourselves noticing that it is different or similar in some way, we are involved in acts of discernment and discrimination (to use the word without its contemporary perjorative associations). Indeed, we are involved in analysis. Art criticism and art appreciation are near neighbours and both are ways into Art History.

Acquiring an aptitude and a skill in looking critically at the artefacts of the past and the present that surround us (or, to use the phrase employed by scholars in Design History and Anthropology, examining material culture) is not necessarily easy. But learning to look in a conscious and self-conscious way is enjoyable. We might be looking at a piece of modern sculpture situated in one of those tiny gardens in the midst of towering skyscrapers where New York office workers enjoy a lunchtime sandwich; or at one of the now almost obsolete red British telephone boxes preserved in a 'sensitive' rural location that attracts our attention; or at an object whose original function was part of an African tribal rite but which now is to be seen in a glass case in a museum like the Pitt Rivers Museum in Oxford. Many of us are able to say with conviction and sincerity that we like art but would find it extremely difficult to say precisely what we like and why we like it. Even when we plan to visit a museum or

gallery, we find ourselves confused, unable to fit things together – though we may be aware that there is a tantalizing pattern which we cannot identify – and, above all, we find it impossible to express adequately in words what our experience of looking has been like.

As children, we learn to draw before we can write but very soon literacy and numeracy become, through school, the criteria of our achievement. Only when we look into the children's dental clinic and see the walls covered with posters of crocodiles with bright, gleaming teeth and rabbits nibbling nuts, or when confronted with a photograph showing a starving child in a famine-stricken region of Africa do we recognize that in some cases the pictorial image is more powerful than words to convey to us a complex mass of information and ideas. Art History requires us, at some level, to regain and cultivate our ability to respond to all forms of visual expression in whatever medium or shape it may appear.

If you think looking and seeing are simple and straightforward matters that are instinctive to everyone, try looking at a picture and describing what you see. Or, even better, look hard at a picture, a building, or any kind of manufactured or crafted object and then go away and try to remember precisely what was before you and what it meant to you when you looked at it. Thurber's witty cartoon (Figure 5) is a clever inversion of the usual 'I don't know anything about art but I know what I like', the layperson's defence against the 'expert'. Just as liking is a vital part of knowing, so knowing is essential to liking. It is the relationship and the developed, cultivated balance between the two that is difficult to achieve. In *Pride and Prejudice*, Jane Austen's heroine Elizabeth Bennett visits a great historic English mansion. She knows that the apartments are full of 'good' pictures but she walks past them in search of something with which she can identify on a personal level. The terms 'good' and 'bad' are problematic for art historians who are more concerned with whether art works fulfil and satisfy the purposes for which they were created than whether they are estimable according to an assumed universal standard. Powerful constituencies in every society construct a notion of what is best. This is called a canon, and it is like a football team; its members may be promoted or demoted, it may be relegated to a different division, and it is controlled as much by international finance as by individual or collective merit.

Museums and galleries (many of which were established in the nineteenth century with the aim of mass education) offer access to visual culture in physical conditions which, though increasingly crowded (and often no longer free) are none the less still generally

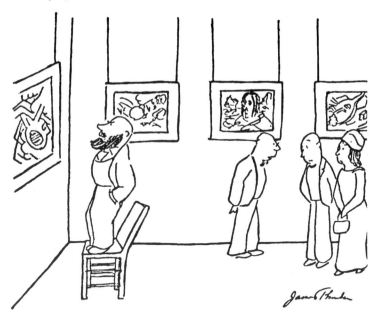

'*He knows all about art, but he doesn't know what he likes.*'

Figure 5 Cartoon by James Thurber, 1943, from *Vintage Thurber*, published by Hamish Hamilton and © 1966 Helen Thurber from *Thurber and Company*, published by Harper & Row

favourable. The institutional atmosphere of some museums may be daunting, but, on the other hand, the more fashionable 'user-friendly' approach is not necessarily more conducive to serious study. When the museum bookshop and cafeteria are the most prominently signposted location in a museum complex, and when other people's hired cassette tours of the exhibition are readily audible as you stand trying to concentrate on examining a painting, it can be very distracting. Though an awareness of why we like certain objects may help in visits to museums, the knowledge that authorities have said that a certain object is 'important' can make us, the uninformed viewers, feel excluded and inadequate.

For all these reasons it is important on entering any institution that displays visual culture to remind ourselves that what we are seeing is not a natural selection but a carefully orchestrated arrangement which results from a series of decisions. These may have been made on grounds of finance, spatial provision or intellectual considerations. Why some things are there and others not, why objects

are labelled in certain ways, and why certain artefacts are placed next to each other are all questions we need to bear in mind and be aware of. If we train ourselves to be conscious of these things, we are then active participants in the collective process of looking rather than bodies being processed through a museum space, enhancing the admission figures rather than our own experience.

For people who live in towns and cities, exhibition and museum spaces are still the best and most convenient places to acquire experience of artworks. Television offers informative programmes, and books containing high-quality colour plates are not hard to find in bookshops and libraries. Most teaching still takes place with slides, videos or photographs, although this is changing as the cost of CD ROMs and the hardware for reading them comes down. It is likely that, with the improved quality of digital imaging (the production of images via computerized data), teaching with new technology will gradually replace the traditional media. But the business of looking – a serious discipline – must involve at some stage engagement with first-hand works of art, whether these be in traditional media (oil on canvas or stone-carving, for example) or in media such as video or photography. Slides, reproductions, books – however instructive – are not a substitute in most instances for the process of first-hand examination. The fact that visitors to galleries seldom spend more than two or three seconds before any single object suggests that, while great numbers of people desire to acquaint themselves with works of art, the relationship between the object and a reproduction with which they may be familiar is a problematic one. It also confirms that looking is a matter of self-education.

The arrangement, conservation and documentation of the permanent collections in museums, and the choice and arrangement of temporary exhibitions, give precedence to certain cultural forms. Thus oil paintings are much more accessible than prints, drawings and photographs, or mass-produced visual material like posters. An exhibition (whether it be a display of objects loaned or part of the institution's permanent collection) is always much more than the sum of its contents; while organizers of exhibitions often feel they are responding to popular taste in promoting a large exhibition of, say, the work of Renoir or Chagall, the total effect of such a show may, paradoxically, be to render the paintings less, not more, accessible. Backed by prestigious industrial sponsors, displaying and cataloguing popular favourites, the exhibition severs such artists from their community and time and enshrines them in a Temple of Art where carefully inscribed labels convey to us a reading assumed to be the

single and correct interpretation for each work, and arrows to tell us where to commence and where to finish. So the process of exploration through looking and interrogating works of art needs to be accompanied by other kinds of study, which will be dealt with later in this book.

When visiting large national collections of art, whether in Britain or in other countries, it helps to plan the visit. Consult a plan of the gallery beforehand (paintings are usually still hung in chronological and national groupings of 'schools') and select what you intend to see. You may change your mind when you get there and find yourself so impressed by something you had not planned to see that you devote all your time to it. If you can make several short visits (and where entrance fees are involved this can be a sore point), this is often much more useful than an exhausting day spent trying to see everything. Mix a bit of looking at things you already know about with things you have never heard of. The familiar is not only reassuring but revelatory if you know it only from reproductions. The new can set you off on a course of intellectual enquiry that you will never forget. In the case of temporary exhibitions, go early in the day and early in the period of the exhibition's showing at that particular venue. As press reviews of big exhibitions proliferate, it becomes very much the thing to have been to see such and such a show and not only are queues involved, but conditions inside can be intolerable.

It may seem from what has been said so far that Art History is essentially a metropolitan activity and that only people who live in large urban centres or people who travel abroad can use the kind of museum facilities I have been describing. This is far from being the case. It is not possible to move the Acropolis from Athens or the Banqueting House from Whitehall for the benefit of students who live elsewhere. Nor will it be possible to see a big loan exhibition of, say, German Expressionist art without visiting one of the big European capitals that is playing host to it. Virtually every area of Britain (and the same applies to other countries where Art History is on the educational syllabus) offers something worthy of attention to the art historian, whether it is the ruins of a Norman castle, a Second World War memorial in a Nottinghamshire village, a set of standing stones in Orkney, an adventurously designed new branch of Sainbury's, a local library that has inherited a collection of objects accumulated by a former serviceman in India, a now disused railway station in Yorkshire, or a stately home now run by the National Trust.

Knowing one's own locality, discovering works of art in local collections, getting to know the work of a local architect or a designer, identifying the idiosyncrasies of a local collector, making a study of any location where visual communication is important (such as a sports stadium or a department store) – these may be as worthwhile for a student as devoting quantities of time and money travelling to a big city to see a special show. While it would be absurd to deny that there are certain events which should be regarded as priorities and which it is worth making an enormous effort to see, the extent to which a journey to London, Paris, Munich or Milan to see a once-in-a-lifetime retrospective exhibition (covering all the works of an artist to date) is rewarding will be largely determined by how much has been learnt about looking and analysing with material available locally. It is clearly the case that more geographically accessible material for study is for the most part European, and that anyone wanting to study pre-Columbian art and architecture (the name given to the civilizations of Central and South America before the Spanish imperial voyages of the sixteenth century) needs at some stage to go to Mexico, Peru, Bolivia and neighbouring countries. None the less, as a consequence of the imperial past of Western European nations, many cities contain extraordinarily rich repositories of artefacts from Africa, Asia and South America. These may be held in a well-publicized location like the British Museum, but many university museums and galleries (East Anglia, Manchester, Edinburgh) hold ethnographic collections rich in non-Western artefacts.

Most of us are astonishingly ignorant of the wealth of visual art available to us within walking distance of where we live. There are many ways in which it is possible to become informed about what to look at and what to look for. A notebook and pencil to be carried at all times are the basic equipment for an art historian. A quick sketch of an architectural detail, a note made of a painting in a sale room or a public place, an analytical drawing of the particular layout of a page in a newspaper or illustrated magazine, help us to develop a good visual memory and may be useful in providing the focus of a piece of research in a local library. Writing down what you notice about the object you are looking at is, probably, the most efficient way of learning to direct one's attention and of acquiring the habit of posing questions even if no answers are immediately forthcoming.

A gallery or museum is not, then, necessarily the best place to start learning about looking for those reasons of cultural history and pressures of public display we have already mentioned. However, in

many galleries and museums there is a person or group of people specially responsible for what is loosely termed 'education'. Sometimes, in large national museums for example, this is a considerable body of people, covering everything from the needs of primary-school children to scholarly symposia on topics related to exhibitions or the permanent collection. The museum education officer's responsibilities normally include liaising with local schools and other institutions. The events that are put on by education departments – usually geared to different levels of familiarity and expertise – are an excellent way of getting to know about aspects of the museum's holdings and famillarizing oneself with the different ways in which people discuss material culture and its histories, for every object will be a part of more than one hi(story).

No museum or gallery ever has all its holdings on display at once. It used to be relatively easy to get to see objects from the store, provided notice was given in advance but, with cuts in staffing levels at virtually all institutions and the imposition of rigorous notions of cost effectiveness obliging cultural institutions to function like businesses, provisions of this kind have been severely eroded. One may have to wait for months in order to get to see something in store at a big London museum. Outside London, people tend often to be more helpful, perhaps because they have fewer requests. For the reasons outlined above, it is not possible to rely on finding open the particular room in the gallery that one came to see. Again, it is the large, 'important', museums like the British Museum and the Victoria and Albert Museum that tend to close certain spaces as they focus their staff on a publicity-attracting event elsewhere in the building. Although all cultural institutions are under government pressure to get sponsorship from business and industry, the fact remains that it is we, through our taxes, who have the primary funding responsibilities for cultural institutions and it is, therefore, our right to have free access to their contents. The much publicised National Lottery raises large amounts of money, most of which goes to the Exchequer. Because the lottery has proved so popular, however, the funds devolved to 'good causes', including the arts, have been considerable (£1.2 billion in 1995, the first year). But this money is not without strings and its overall long-term benefits to the arts are open to question: only capital projects are eligible and applicants must be institutions (not individuals). Moreover, those applying must themselves raise a proportion of the total needed. So there are many gallery extensions, cafeterias and theatre restaurants under construction; whether those same galleries will be able to conserve

their holdings in appropriate conditions, pay their staff, let alone promote new art and acquire new objects is another matter. We should never forget that the treasures housed in public museums and galleries (often there as a result of the generosity of someone long dead who wished the pleasure of their collection to be extended gratis to a wide audience) belong to everyone and, whilst one of the curators' and keepers' responsibilities is that of safeguarding, researching and improving collections, it is equally their responsibility to answer questions from the public and help people to acquaint themselves with works of art.

There is increasing sympathy for the view that a person can only know a Mies van der Rohe chair by sitting in it or a sculpture by touching it and handling it. Clearly there is a problem here. If everyone wanted to experience the physicality of delicate items in collections, the function of the museum as guardian would have to take precedence over the function of the museum as educator. The Isenheim altarpiece in Colmar can only be properly understood as an object possessing a whole series of viewing possibilities with overlapping and intersecting meanings if it is comprehended as a three-dimensional object with panels which open and close, revealing and concealing, offering an inside and an outside in a complex interplay of signifiers. The use of diagrams, models and mirrors can sometimes help to compensate for the fact that we cannot see this movement from stage to stage and no one would argue for the right to handle an object of such antiquity and physical vulnerability.

The staff of museums and galleries outside London frequently have at their disposal useful information about artworks and buildings of interest in the area covered by their museum's service. For obvious reasons of confidentiality, they are not always willing to impart this information, but it is certainly worth approaching them for details. Other important sources of information are local history libraries (usually a department of the central municipal library) and county record offices. Organizations like English Heritage, the National Trust, the Georgian Society and the Victorian Society will provide information about buildings of interest in your area. If there happens to be a site of special historical interest in the locality, this may be covered by the activities of a local civic society or preservationist pressure group. By joining one of these groups it is possible not only to gain access to art-historical material that may be experienced at first hand but also to do a useful job for the community and acquire expertise in research, records and presentation. For those working in medieval art, local archaeological societies are often

a fruitful source of information. The local library, museum or town hall usually has information on such bodies.

It is advisable, having selected an area of study, to narrow it down as much as possible. It is usually more rewarding to get to know one Norman church in your area or one aspect of the work of an artist than four churches or the whole of one person's work. In the same way, studying one painting in a gallery rather than looking at a roomful of pictures is the best way to acquire skills in looking. Many people take holidays abroad and use guidebooks, which often list major historic sites of interest. One such series, available in paperback, is the revised and recently reissued Blue Guides, published by A. C. Black, London. However, none but the most specialized books of this kind offer any detailed information. It is possible, however, to plan in advance what to see in galleries and institutions outside Britain by consulting the *International Directory of Arts*, which is published (in English) in Germany and frequently updated. It includes information on the location, contents and opening-times of thousands of museums and galleries around the world and is held in most reference libraries.

It may be that what you have chosen requires no special access; an analysis of the visual arrangement employed to attract customers into a competitive market and an evaluation of the meanings and associations produced in that arrangement (baked beans by a certain manufacturer equals a happy childhood; a brand of underwear makes you a real man) might require a number of visits to a shopping centre which is conveniently open during extended working hours. A study of style in clothing of any group (football fans abroad, visitors to Ascot, teenagers in a club) would require a very clear set of definitions of that group and a sense of the geographical location of their self-presentation.

Practical considerations are important. Plan a programme of work including several visits to a site, some relevant reading and consideration of the method and approach to be used. If relevant, ascertain opening-hours before setting out and, if your destination is a church or a country house (many of which are closed from October to March), or if you are likely to want to see something not normally shown to the public, write in advance to the vicar, the estate manager or the curator to request permission to view your chosen material. It can be particularly frustrating to reach a remote country church to find it all locked up and the vicar away on holiday or visiting in another parish. Certain objects are only shown at certain times of the year. The National Gallery of Scotland only shows its Turner

watercolours in January, when daylight (a destructive agent to which watercolour is particularly subject) is weakest. Avoid peak holiday periods if possible and choose clear, bright days. The stained glass in a church will not be seen in all its brilliance on a wet, dull day and although many galleries are now completely artificially lit in the interests of preservation, there are still major picture collections housed in galleries with huge glass roofs and, in these cases, the better the natural lighting conditions the better the experience of looking. Some documents, like newspapers and journals, are now available to the public only on microfilm, so it may be important to book your visit in advance and reserve a place on a microfilm reader.

A preliminary look at your chosen object will not only help you to establish a visual relationship with it but will also assist in identifying the questions that need to be asked about it. Go away after an initial session and work out a questionnaire or a series of headings under which to work. The discussion in Chapters 2 and 3 should help direct your study. Though you will want in due course to tackle the question of what others have said and written, it will help you in dealing critically with that published material if you have sorted something out for yourself first.

Art historians need equipment; most of all they need their critical faculties, but when they are engaged in 'fieldwork' more practical tools may also be useful. Geologists take hammers with them and entomologists take nets. A hardbacked notebook of the type that has one page lined and one page plain can be very useful for the kinds of recording I have described earlier. The antiquarians of the seventeenth and eighteenth centuries, the predecessors in an important sense of today's art historians, relied on drawing as a way of making a record but also as a way of registering, or noticing, all the important elements in an object under scrutiny. A camera does not impose that discipline but rather inclines us to feel that we have looked at something when, in fact, we have merely looked through a camera lens. A camera is often a great asset, though it may also be a considerable nuisance. Not only is it exhausting and inconvenient to have to carry around a lot of photographic equipment but, more important, there is a danger that the camera will make you more intent on taking the photograph than on examining the object. Many art galleries will not permit visitors to take photographs. Buying good quality black and white photographs as a research tool (as opposed to picture postcards which are, of course, available in gallery and museum shops but restricted to a small range of the most popular items) is extremely costly even without the additional

copyright fee that is charged to anyone wishing to reproduce them. The minimum you may expect to pay is around £8 plus VAT and the price rockets if the gallery does not already have a negative. You may also be joining a large queue when you order your photograph! It may seem surprising that galleries and museums do not have a photographic record of every object in their care, but such is the case and it is a sad manifestation of the under-funding in Britain of the repositories of our cultural heritage. Some galleries and museums are, however, extremely helpful in the matter of photography. The picture libraries (i.e. the departments that handle photo orders) of the National Portrait Gallery and the Victoria and Albert Museum now charge reduced rates to *bona fide* researchers. The Victoria and Albert Museum is also one of a small but helpful group of international museums where, provided you do not use flash or set up a tripod, you may take your own photos.

Photography is, like drawing and writing, a medium of communication. Whenever we record anything, however 'objective' we aim to be, we are interpreting and our medium (photography, pencil, ball-point) will mediate what gets on the record. So think about this as you position yourself to take a photo or begin a sketch. Elsewhere in our art-historical engagements we may want to think more closely about these modes of communication – the way the apparently scientifically accurate and truthful account is also always an act of interpretation. But this does not preclude our recognizing that, in so far as art historians in one aspect of their work examine and evaluate historically objects which have a physical existence, in doing this they have to record what they see in order to be able to compare this with what other people claim to have seen.

There is a lot of footwork involved in looking, whether it be in a museum, in a city street or in the countryside. It goes without saying that comfortable shoes can make all the difference to the day, and if you happen to be exploring Stourhead Gardens in Spring or Kensal Green Cemetery in winter, wellington boots are a necessity. A tape-measure is a useful piece of equipment for the art historian. A ruler is very convenient for measuring the dimensions of a painting or drawing and a dressmaker's tape-measure for recording the girth of a column. A pocket magnifying-glass and a pair of binoculars can be very useful too. It may perhaps seem that these things are superfluous for someone who is not writing a definitive study or making some kind of report. But the fact is that apprehending the material existence of an artefact should involve a comprehension of it as a three-dimensional and concrete presence.

Obviously, to look at stained glass through binoculars is never to see it as it was intended to be seen. One the other hand, the full quality of colour and the effectiveness of technique cannot be appreciated without a closer look. The art historian wants to know not only what it is but how it has been made. Similarly, the magnifying-glass is not only used by art historians to authenticate a work or to examine a signature but can assist towards knowledge about how a work was constructed (what sorts of pigments and brushes or knives were used in the case of a painting) and how it was produced (how many wood blocks were used to make up a plate for a magazine, indicating how many engravers may have been at work on that one task).

Looking at buildings requires a different discipline from looking at sculpture, paintings and other art objects. It is important to take into account considerations like the season and the weather and the time of day. Is a building being seen under typical conditions? This is an important question. The relationship of a building to its surroundings, whether natural or man-made, might appear different in winter from in summer. At certain times of the day architecture, particularly public buildings, has a more obvious function than at other times. If you are visiting an office block, study it as a working, active edifice rather than as a place in repose. Make sure you know what it feels like at 9 o'clock in the morning and at 5 o'clock in the evening when those who work there are arriving or leaving.

The relationship of exterior to interior is fundamental to architectural study, as is the relationship of the building to its environment. It is necessary to do more than merely look from the outside. Request admission and move about inside the building. Find out what the experience of the building is for those who work in it and make enquiries as best you may to find out what adaptations have been made in the construction of the building since its erection and what changes in function have taken place. Is life in the building easy or difficult, pleasant or unpleasant, for those who travel in its lifts, deliver materials to its loading bays or look out of its windows? What must it have been like in the past? Consider the structure as a whole, taking into account the furnishings and fittings as well as the actual fabric. In the case of country houses, and also with some museums, your route is prescribed for you; this makes it all the more imperative to try to imagine other routes and other viewing positions.

Many modern buildings take on a quite different appearance with the introduction of human movement and colour. The Lloyds building in the City of London offers a very different appearance at

night from in the day, when its gleaming surfaces are enlivened by colourful moving figures. The needs and characteristic patterns of movement of the population have to be taken into account when studying architecture. Sometimes, for example, it is possible to observe that, in laying out paths and walkways, the architects or planners have made inappropriate or inadequate provision for the consumers, and the scarred turf or broken balustrade bear witness to the pedestrian's natural routes.

In cases where alternative use has been found for a building (cinemas and churches are now frequently in use as anything from private houses to bookstores), it is important to arm oneself with the clearest possible information about what it was like in its original state. Recourse to the local library is the best first step. Here early histories of the locality as well as maps and plans can often be found. By bringing together current, on-the-spot observation and a little personal research, an interesting reconstruction can be made.

In looking at sculpture, one of the most important considerations is where the sculptor intended the work to be placed. Column figures from Gothic cathedrals have found their way (in the interests of preservation) into museums, where their precise function and their role as part of a total structural concept have disappeared. Monumental sculpture, which may have been seen, when *in situ*, from 100 feet below and which was, therefore, designed to be seen in daylight from a distance, may now be placed in artificial lighting in a cramped corner of a museum. Sculpted figures that were made for specific religious purposes – as, for example, with Hindu sculpture from India or Buddhist cult objects from China – are difficult to understand when placed in a glass case in a Western museum, however much their beautiful shapes inspire admiration. The loss of function (whether practical or symbolic) sometimes leads to aestheticization – to the promotion of the object as a thing beautiful to look at and tinged with an aura of antiquity but lacking any history. The fashion for museum displays of material culture in the USA has often produced a situation in which, for example, a shop sign or a piece of agricultural machinery is exhibited suspended in isolation on a white-washed wall.

Naturally it is necessary when looking at sculpture and architecture to be conscious of the changing viewpoint. Walk around and examine the object of your attention from every side. Touch it, feel it, look through it, above it and below it. If the sculpture is placed out of doors, make sure you see it in different weather conditions. Rodin's *Burghers of Calais*, one version of which stands in the town

square of Calais, presents a very different aspect when the bronze figures are wet and reflective from when it is gleaming dully on a sunny day.

With works of applied art, it is especially important to see the object in its appropriate surroundings. This can be problematic. A chair or a length of textile conveys a different visual message to the viewer according to its setting and according to the nature of the objects placed around it. One Biedermeier chair may be a beautiful object on its own but its special characteristics of design and the way it works visually can only be appreciated if it is seen in historical context, that is in a total Biedermeier interior. Unfortunately, it is seldom possible to do this, but one can go some way towards establishing the relationship of an object to its surroundings. If you cannot, for example, view a Lalique vase in a contemporary setting, then try to find an art nouveau interior of the period to which the vase belongs and study it alongside the object. Failing that, there are always photographs and descriptions which may be of considerable help.

Audio guides (cassettes with headphones offering a taped commentary) are now a commonplace not only in big exhibitions but also in the permanent collections of major galleries. For those with serious aspirations to art historical activity audio guides used to be despised as only fit for those who didn't know what they wanted to see. It must be said, however, that the audio guides available, for example, in the Tate Gallery and the National Gallery in London (Tape Inform at the Tate and Gallery Guide Soundtrack at the National Gallery) though basic, have real benefits: the commentaries are intelligent and by no means condescending, they are available in a variety of languages, and most importantly they permit viewers to select which individual paintings they wish to examine. The National Gallery guide is accompanied by a floor plan and small individual reproductions of the selected paintings with their room and accession numbers. The sound track is activated by tapping in the sound track number shown on the label beside the painting. It is important not to forget that only a very small selection of works are included on any audio guide.

Some galleries and museums have adopted interactive technology for their displays. One such is the Museum of the Moving Image in London (MOMI) which offers many exhibits which visitors can manipulate by pressing buttons for particular selections: a magic lantern can be spun and visitors can select highlights of British television under a number of categories. There is a danger of displays like this becoming a magnet for children intent upon pressing as many

buttons as possible, but it does make complete sense to experience a moving medium in this way even though the displays at MOMI are spectacular rather than informative. Indeed, it is only by participating in the working of early optical toys and experiments that we can understand the historical development of film. In the case of galleries with major collections of paintings, it is often now possible (as at the National Gallery) to search via an interactive computer program for what you might wish to see in actuality (such as all flower paintings, or all paintings containing images of saints).

Installation art – and some of the most controversial productions of contemporary artists fall into this category – poses distinctive problems for viewers. Indeed, one of the salient features of this kind of art is precisely that it does make seeing difficult, both in the sense that whatever is offered may be ephemeral, and in the sense that visitors' traditional ideas about where to stand and how to look are undermined and challenged. Helen Chadwick's *Blood Hyphen* (1988), for example, was sited in the Woodbridge Chapel, London, where Chadwick removed a panel in a pre-existing false ceiling above the pulpit so that a second space appeared to float above. A blood-red beam of laser light pierced the darkness and lit an enlarged photographic panel showing the artist's blood cells. It is now known only from photographic records. Richard Wilson's work *20:50* (1987) is installed in the Saatchi collection; consisting of a steel walkway extending between two shoulder-high vats filled with black sump oil with reflective qualities, it demands from viewers a series of decisions which are quite different from, say, those required of a statue by the Italian Renaissance sculptor, Donatello.

Performance art is, of all media, the most ephemeral, involving a 'one-off' event or sequence of events often necessitating the actual destruction of the material components used. When, for example, in 1974 Marina Abramovic performed *Rhythm 5* (in Belgrade) the props comprised a large five-pointed star constructed of wood and wood shavings and soaked in petrol. Passing around the construction, Abramovic threw a lighted match that set it aflame and then, after cutting off her long hair and dropping bunches of it into each point of the star, she lay down in the centre.

2 Art History as a discipline

In the following pages I shall try, without smoothing over the differences and complexities, to point to possible ways into and around the discipline of Art History, and to introduce readers to some of the different methods and approaches currently practised by art historians. In this book, Art History is the term employed to denote the discipline that examines the history of art and artefacts. So History of Art is what is studied and Art History is the cluster of means by which it is studied. To complicate matters, those who want to be precise about their use of language – recognizing that the words and phrases we use are not neutral and suggest the relative importance and values we attach to the things we speak of – talk not of History of Art but of histories of art. Losing the capital letters and replacing the singular by the plural thus enables writers or speakers to distance themselves from the notion that there is, by something like a process of natural selection, one unquestioned and universally accepted view of what constitutes history. Whose history, and art by whose definitions? These would be the kinds of question posed to challenge magisterial accounts like Sir Ernst Gombrich's *The Story of Art*. First published in 1950, Gombrich's bestseller was re-launched in 1995 in a dust jacket replicating a stone tablet on which the author's name and the title appear as incised letters, an effect calculated to suggest the authority of Old Testament law. This marketing strategy plays on the idea of a singular authority; it is precisely this notion that is challenged in works with titles like *Vision and Difference: Femininity, Feminism and the Histories of Art* (by Griselda Pollock, published in 1988).

In later chapters, we shall see how we can most readily discover what we want to know, and we shall examine ways of organizing our looking at historical artworks and how to structure our reading to the best advantage. First let's look at what the education system

offers, because the whole subject is very confusing for those who
are wondering whether to take a degree course in art or to pursue
the study of the history of art on their own or in an organized group.
To begin with, 'fine art' is a term which has often been used in the
past in a general way to describe painting, music, drama, sculpture
and other art forms. In this sense, the fine arts are those generally
that are distinguished from the useful or mechanical arts but in the
contemporary British education context Fine Art usually means
the practice of painting for its own sake. In the USA most univer-
sities teach Art History alongside studio-based learning (art practice)
in Departments of Art. In Britain, for historical reasons, the situation
is different. Some universities offer degrees in practical art and Art
History in the same department or within the same organizational
unit (a School or a Faculty) and it is possible in such institutions
to take a degree course that combines history with practice. It is,
however, relatively uncommon and most students opt for either a
degree course that is essentially historical and theoretical (though,
of course, the focus may be on the modern and contemporary) or
for a degree course in some aspect of art practice normally preceded
by a foundation year. Some degree courses combine history of art
in the traditional sense of painting, sculpture and architecture, with
history of design, and many institutions offer not only single honours
History of Art but combinations with other disciplines (History of
Art with a modern language is common but also available are, for
example Art and Archaeology of the Ancient World at Manchester
University while at the University of Northumbria History of
Modern Art is offered along with History of Modern Design and
Film). Some institutions participate in the EU student exchange
scheme ('Socrates') whereby individual students from one country
may take part of their course in a university in another member
country. It is very important when considering applying for a course
to look very closely at course descriptions as well as overall provi-
sions within the institution.

The term 'visual culture' may be used to include a considerable
range of periods and objects of study. Many universities offer
modules on subjects like 'heritage and history' or 'historical and
theoretical studies in photography' (University of Derby) but if
you are keen to devote most of your time to art historical study you
need to make sure that the institution to which you are applying
offers enough modules for you to attain your objective. A small
department may offer a degree course that concentrates on a partic-
ular area of period (the University of Lancaster, for example offers

Art History and Culture: the Twentieth Century) whereas a large department may offer not only considerable chronological span but also several different degrees. In good American universities it is unusual not to find an Asian or Far Eastern specialist but there may be no architectural historian, in this country the reverse is the case. If you know you want to study Chinese art, then look very carefully at the prospectuses of the various institutions to ascertain where tuition in that specialism is offered. Some universities have no History of Art department: at time of writing this is true of Exeter, Southbank, King's College, London, Southampton, and Stirling.

Being a good researcher and a distinguished scholar doesn't necessarily mean you are good at communicating to undergraduates; departments of History of Art (as with those of any discipline) are only as good as the creativity and learning of the people who teach in them. The results of the peer assessment of university research, conducted department by department at the behest of government every three years, are in the public domain, as also are the results of teaching quality assessments. Institutions are in keen competition for good students. Although, if you are sitting school exams, you may not feel like the proverbial consumer with a market choice, this is precisely what you are and, since this purchase will affect your whole life, you need to do your homework and be sure to get it right.

Art History is also taught in some (though not very many) schools, in sixth-form colleges, further education colleges and technical colleges. It is also available in some centres as part of the 'Access to Higher Education' programme for over-twenty-one year olds. If you live in reach of a town, it is often possible to sign up for 'A' level History of Art (as the exam is called) even if you are not planning to go on to take a degree. Other organizations also offer Art History courses: the Workers' Educational Association, many university centres for continuing education, museum education departments and the National Association of the Decorative and Fine Arts Societies all run courses on topics connected with the history of the arts. In London, the Courtauld Institute, the Architectural Association and the auction houses Christie's and Sotheby's all run short courses as well as providing postgraduate tuition. The fees charged by these organizations vary hugely, as does the level at which tuition is provided, so check carefully that what is on offer is what you want. People who already have a degree (or commensurate experience) in another discipline can sometimes find that a postgraduate diploma course will provide a 'conversion' for

them, introducing them to Art History but at a more advanced level than the first year of an undergraduate degree. One of the most popular among such courses, and serving as an excellent lead-in to further study in the discipline, is the diploma course run part-time by Birkbeck College, University of London. One year post-graduate diploma courses are available also at the University of Oxford, Goldsmith's College, and the Universities of Warwick and of Central England. Masters degrees by taught course and post-graduate courses in, for example Museum Studies are on offer in a large number of departments and should also be selected with care.

Art historians often get asked 'Do you paint as well?' While the view may be held that only those who make their own art can really give an authoritative view of the art of the past, it is more generally the view of art historians that the discipline is in itself a creative activity and those who are artists as well as art historians can be wholly committed neither to the one nor to the other. It is certainly true that artists have always studied art and creatively exploited the work of their predecessors (whether consciously or not). How they did this has fed into the debate about education and the National Curriculum with the argument that all children should know the names of 'great artists' like Raphael and Michelangelo. The artists who appear in this canon are, indeed, often those who have had an 'influence' on other artists simply by virtue of the fact that the canon is formed in a long, cumulative process. The trouble is that there were no named great artists in the Middle Ages, though I suppose you could teach a class to recite the names of the great Burgundian cathedrals rather like Victorian children learning the Seven Wonders of the World.

More importantly, this sort of systematization grossly simplifies history, substituting names as answers where questions about *historical process* should be asked. Moreover, it is not always the canonical artists who have been influential. The artist who features most prominently in the art criticism of Baudelaire in nineteenth-century Paris, and whom he admired beyond measure, is a man called Constantin Guys, whose work is scarcely known today. John Flaxman's run-of-the-mill engraving work (certainly not canonical) probably distributed more pictorial motifs around Europe in the 1800s than any other work of art ancient or modern. The work of Botticelli (Figure 6), so admired by visitors of all nationalities to the National Gallery in London today, was 'forgotten' for several centuries and 'rediscovered' only in the late nineteenth century, suggesting that the idea of abiding quality and permanent value is a chimera.

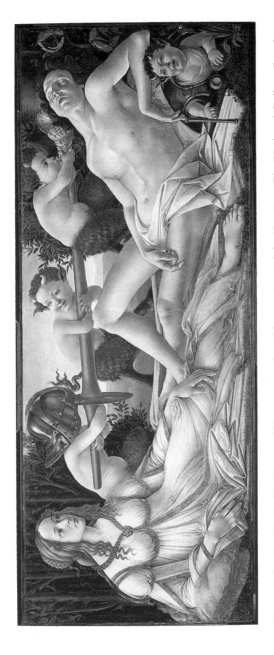

Figure 6 Sandro Botticelli, *Mars and Venus*, reproduced by courtesy of the Trustees, The National Gallery, London

The relationship of artists to their predecessors – the contact between practice and history – is no simple matter and needs to be understood in terms of a two-way process. When we see a famous portrait of the Pope represented in a painting by Francis Bacon (Figure 7) it affects not only the way we think about Bacon but also the way we think about Raphael's Pope Julius II. The use by artists of earlier material and motifs is always at some level an interrogation of culture, of painting's aftermath. Paula Rego's splendid *Tales from the National Gallery* (Figure 8) (a series specially commissioned by the National Gallery and now hung in its Brasserie) makes overt and apparent the complex engagement of parody, commentary, commemoration and incorporation that occurs when the practising artist self-consciously adopts the historian's position.

The issues raised by this discussion are clearly of relevance to today's student of art. For them the controversy centres, not surprisingly, on whether art students can be 'taught' the art of the past or whether they have to discover unaided what might contribute to their own effort to create. But the teaching of the history of art to students of practical art is based, rightly or wrongly, on the assumption that a helping hand, a discipline within which to organize encounters with works of art, the proffering of material the student might not otherwise come across, is generally enriching and can be directed specifically towards the individual's own area of artistic practice, whether that be ceramics or graphic design.

The origins of Art History are variously located. Some people would argue that they lie in the nineteenth century, when those responsible for assembling national collections of art in Germany and England began cataloguing and writing the histories of the works they were purchasing (or obtaining by military conquest). Others would put the date very much earlier, in the Renaissance, with Vasari's *Lives of the Artists*, or even earlier, in Roman times, with Pliny's accounts of the artists of antiquity. As a profession, with its own methodologies, Art History originates in Germany and Austria at the end of the nineteenth century and the beginning of the twentieth. One of the consequences of the movement of refugees from central Europe earlier this century was the introduction of many distinguished individuals and libraries connected with Art History into the UK and the USA. One of the most famous of the immigrant scholars to Britain was Sir Niklaus Pevsner, whose series *The Buildings of England*, organized county by county, remains the richest architectural survey available. The resources of the Warburg Library at the University of London were the bequest of Aby Warburg, a Jewish refugee.

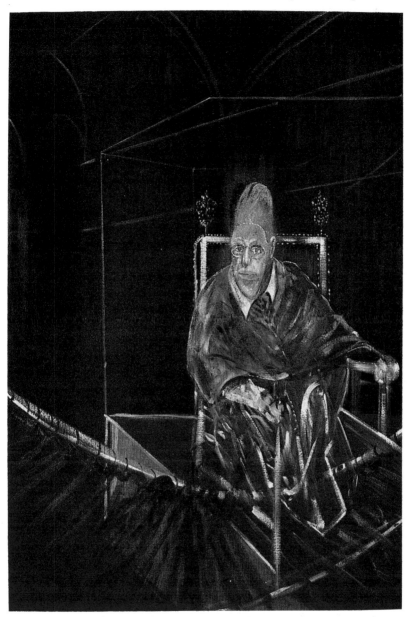

Figure 7 Francis Bacon, *Pope I*, 1951, Aberdeen Art Gallery

Figure 8a Paula Rego, *Crivelli's Garden*, reproduced by courtesy of the Trustees, The National Gallery, London

Figure 8b Paula Rego, *Crivelli's Garden*, reproduced by courtesy of the Trustees, The National Gallery, London

Figure 9 The 1930s kitchen, from L. B. and A. C. Horth, *101 Things for the Housewife to Do*, Batsford, 1939

Design History is of even more recent origin. It is a discipline in its own right, with a small but growing literature and its own journals, for example *The Journal of Design History* and *Things*. It overlaps with the study of material culture (i.e. artefacts which may be utilitarian and functional as well as/rather than aesthetic) which takes place in the context of Social and Economic History, Anthropology and Art History. There are many cross-overs between Art and Design History, but the latter encompasses a somewhat different range of objects from Art History. While the two might share a concern with, say, the organization, layout and contents of the Great Exhibition of 1851 held in the Crystal Palace, Design History addresses consumer culture in a much broader way, looking not only at the shape and form of manufactured objects but also at the economics of distribution, at the psychology of marketing and, in a holistic way, at how environments (the 1930s kitchen (Figure 9), the 1950s office) are shaped and constructed in meaningful ways.

* * *

Art History is concerned with no single class of objects. As we have established, every 'man-made' structure and artefact, from furniture

and ceramics to buildings and paintings, from photography and book illustrations to textiles and teapots, comes within the province of the art historian, though traditionally Art History in educational institutions has concentrated on the trio of painting, sculpture and architecture that goes back to Renaissance writers like Alberti and Vasari. Similarly there is no one identifiable Art History; scholars and groups of scholars develop interests, and methods to pursue the questions raised by those interests, that are often fiercely oppositional. Approaches to the documentation, analysis and evaluation of visual material, as with any other form of human production – music, literature, politics, agriculture – can be very disparate.

There is, for example, a mode of enquiry that has as its premise a view of cultural history or communications in which the particular objects studied – paintings included – are examined as commodities within a system. The important thing here is to understand the system and how it works, not merely in terms of how it is organized but also in terms of the symbolic values it generates. Such an analysis is fundamentally concerned with power, with control and with economics. Thus, for instance, the art auction might be an object of study not for the individual items that are being sold there but for what we can learn about the transaction and exchange of values in Western society. Money is spent at auction, but what is purchased has a value and a symbolic meaning within a political economy that extends beyond the economic and monetary value. Why do people buy old things? When Andrew Lloyd Webber, millionaire composer of musicals, 'saved' a view of London by the eighteenth-century artist Canaletto, a painting destined for export, what exactly did he get with his money, and on behalf of whom was the purchase made? What status do acquisitions offer the people who buy them? What rules are followed? What rituals are practised? And what social and class boundaries are crossed through the acquisition of objects? The collecting of Fabergé eggs by the millionaire American newspaper tycoon Forbes might, in this sort of study, be understood to accumulate meaning from the fact that such luxury products of the celebrated St Petersburg goldsmith working in the early years of the twentieth century are associated with the Tsar of Russia, one of the world's great hereditary rulers. Abbot Suger of Saint-Denis in Paris in the middle of the twelfth century left a detailed account of the vast expenditure lavished on the abbey church in his care. It is possible to read this account (and the letters to him from St Bernard, who disapproved of lavish display by the clergy) as a

discourse upon conspicuous consumption and asceticism in a feudal Roman Catholic society.

On the other hand, maintaining the traditional concerns of the discipline (and increasingly concentrated in museums), are art historians for whom not only is the object or artefact of prime importance but that object offers up its own answers. These art historians work on the assumption that paintings and other works of art 'speak' directly to us as viewers, that our access to them is unmediated by the historical and social positioning of us as viewing subjects. By responding to purely visual characteristics (form, colour, composition, brushwork) we may, is the implied assumption, gain access to the essential genius of the artist and thence to an understanding of the summary characteristics (the 'tendency') of an artist, a school or a whole period. It is not only in evidently traditional contexts that this kind of Art History holds sway. Here, for example, is a passage from a book about painting and the cinema:

> The subject matter in Callot's scenic works is seamlessly narrative rather than anecdotal. Drama is seen as a dynamic flow, not a set of well-shaped phrases. The Opening of the Red Sea and the Carrying of the Cross have a dazzling panoramic integrity beyond any requirements of the story, and free of a painter's need for stable chromatic schemes. His method is related to that of Breughel, though quite different; related, because these two artists share in the sense of the kinetic scene and the kinetic eye and so both prefigure film; different, because of the different aims and means that made them ancestors of different styles of film.
>
> (A. Hollander, *Moving Pictures*, Cambridge, MA: Harvard University Press, 1991, p. 113)

In this kind of writing, the account of the artwork is tautologous because it relies on an explanation that refers to another artwork as it is understood by a twentieth-century eye. There is no reference to anything outside of the cultural objects, which are thus linked together in a continual chain of reference.

The issue of quality is of immense importance in this sort of art-historical practice (is this a 'good' Cézanne or a 'less good' Cézanne?), which works on the assumption that there is an agreed scale of values that operates universally and across time. The aesthetic experience is an important starting-point, though tracing the history of the object, and thus establishing its authenticity, is equally necessary. It might be a painting, a bronze figurine, a drawing or another kind of artefact. As this kind of enquiry is essentially

object-based the art auction in this instance provides the means to an analysis of individual items. It is not of interest as a phenomenon in itself. Thus an art historian practising in this particular way would locate in an auction, or with a dealer, a work which may have been 'lost', may have disappeared from public view for several generations. Supposing it was, say, a painting by Rubens, it would be possible then to slot this into the pattern of Ruben's lifetime's work (his *oeuvre* is what it would probably be called by art historians) like a missing piece in a jigsaw puzzle. Filling the gap might change how the surrounding bits look, or it might raise questions about bits which looked all right before.

Object-based art history does not have to preclude a consideration of function (whether practical use or symbolic purpose) but in actuality it does. Moreover, it tends to be in contradistinction to the approach which, evolving in the late 1970s in response to major rethinking in the human sciences, has often been called 'New Art History'. The notion that there is one group of people finding out the facts about objects (often people based in museums) and another group of people dependent on this work and producing interpretations has been well and truly challenged in the last three decades. It has been argued that the conceptualization of 'facts' and the decision about what questions to ask of an object are also matters of interpretation. The idea of academic objectivity has been discarded by many art historians who now acknowledge that reading paintings (the term is significant because it recognizes that the viewer plays a part in interpretation and that any form of representation may be seen as a text to be 'read') involves multiple meanings which will be to an extent determined by the constitution and environment of the individual doing the reading. Here, for instance, is part of the concluding passage in an analysis of Dürer's engraving entitled *Promenade*, which shows a man and a woman taking a walk while a figure of Death in the form of a skeleton peeps at them from behind a tree (Figure 10):

> In an image which becomes increasingly more complex and elaborate the more it is examined, we are prevented from neatly summarizing meaning or content. This is in large part because so much of the formation of meaning is to be provided by the individual viewer – it does not reside in the image to be identified and deciphered. And surely it is significant that Dürer treats a theme of Love and Death in this manner: diversity of reference, complexity of meaning, and the self-referentiality of the reading

of this image are peculiarly appropriate to the themes of Love and Death, which are interrelated in a deeply psychological sense, linked to one another and to man in his most fundamental myths.

(M. A. Meadow, 'The observant pedestrian and Albrecht Dürer's *Promenade*', *Art History*, 15, no. 2 (June 1992))

There is much overlap and interrelated activity among different art-historical practices, and the examples I have given are intended only to suggest different types of engagement. The discussion that goes on between different areas is itself a part of the attempt to define and re-define ways of dealing with visual communication. The traditional art historian's concern with quality, the implicit belief that some things are better than others, is constantly a matter of debate. Few would argue that a sculpture by Bernini has more capacity to delight the viewer with a range of sensations and interests than an Action Man doll. But that does not mean that the role of the doll in the formation of American ideas of childhood and masculinity in the 1960s is less worthy of investigation than Bernini's relationship with the Barberini family in Rome in the seventeenth century. What is more difficult is the argument about whether a photograph by Robert Mapplethorpe, with its calculated effects of dark and light and its challenge to expected notions of how the human body is represented for social consumption, is a quality work whereas a pin-up from a pornographic magazine is not. The question is: who decides whether something is good or not, on what criteria are such judgements based, and to what uses are the judgements put?

Authenticity is an issue which, at a general level, distinguishes Art History from comparable disciplines like English Literature. Certainly some poems are anonymous, particularly works from earlier periods, but by and large we know who produced what – which is more than can be said for many visual works of art. When Giselbertus signed his name under the portal of the great cathedral of Autun in France under the marvellous carvings executed there in the twelfth century (Figure 11) this was a most unusual act, a turning-point in the history of art. The identity of the artist became a matter of increasing interest in Western culture, so much so that the signature has become invested with almost magical powers; it is understood to guarantee the reality of the artist as a person and, of course, it stands as a defining mark which ensures a market value.

As a result of workshop practice (from the Renaissance to the nineteenth century Western artists worked in groups around a master) it is often difficult to distinguish who did what. Even when,

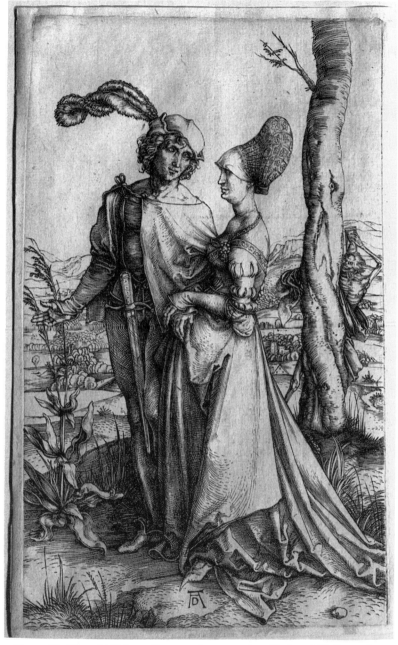

Figure 10 Albrecht Dürer, *Promenade*, engraving, National Gallery of
Art, Washington DC

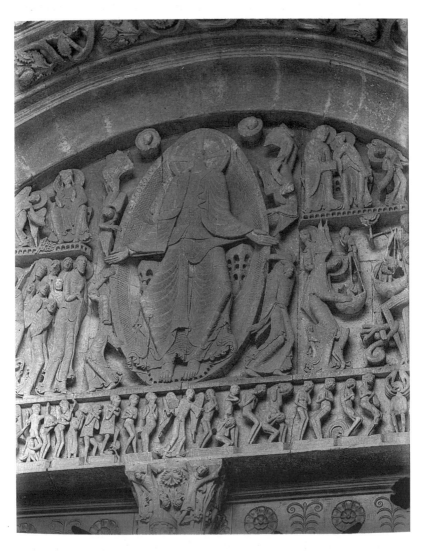

Figure 11 Autun Cathedral, France, the tympanum of the great
west door. 'Giselbertus hoc fecit' is carved under the feet of Christ.
Photo: Conway Library, Courtauld Institute of Art

in more recent times, the status of artists and sculptors became more elevated and they were gradually regarded less as artisans and more as specially gifted and respected members of society, many artists have preferred not to sign their works. David Hockney has challenged the very notion that originality and authenticity lie in the work of art as unique object by producing FAX art. Sometimes, for legitimate as well as dishonest reasons, later generations have added signatures to works of art which can be very misleading to scholars and dealers alike. There have also been many cases of misattribution; some of the work of the seventeenth-century Italian artist Artemesia Gentileschi, for example, was until quite recently attributed to her father.

It is certainly true that students of English Literature will at some stage confront bibliographical problems: the mistakes made by printers, the variations on a single line which appear in manuscripts or proofs of poetry, the emendations of editors through the ages, the piecing-together of incomplete documents, and so on. There is great uncertainty among scholars as to which is the 'original' text of Shakespeare's plays. But grappling with these problems is a highly specialized procedure and most teaching of English at sixth-form and undergraduate level assumes a permanent body of literature by known authors that can be read and enjoyed and discussed. The question of authenticity is, however, of major importance to art historians and necessitates modes of enquiry that have little relevance to studies in literature.

It is because traditionally one of the characteristics of the visual work of art has been its uniqueness that art historians are sometimes as much preoccupied with locating and authenticating as with interpreting. It is mainly in connection with painting and sculpture that technology plays an important role. The examination of paintings through infra-red photography, the process known as dendochronology, through which the age of a wood panel can be assessed by counting the rings on the wood, and many other scientific processes are used in the search to identify and accurately to date works of art. Contemporary art, as I have just pointed out in relation to Richard Wilson and David Hockney, is often involved with challenging these assumptions. Ideas of time, decay and natural (as opposed to artistic) processes are, on the other hand, the very things which are explored in the installations of the German artist Joseph Beuys, whose work has incorporated built-in possibilities of physical change, with animal corpses and other natural material sealed into glass containers, or in the (in)famous *The Physical Impossibility of Death in the Mind of*

Someone Living (1991) in which Damien Hirst placed a shark floating in formaldehyde solution in a steel glass panelled case (Saatchi Collection).

The apparent uniqueness of many works of visual art is something that has often been seen, therefore, as setting Art History apart from its fellow and interdependent disciplines. The student of English may feel a thrill of excitement on first reading a play by Samuel Beckett and may be moved to go and read Beckett's other work, just as the student of History of Art who is stirred by the sight of Titian's *Bacchus and Ariadne* may seek out other paintings by the same artist. The student of English may not immediately and conveniently be able to attend a performance of *Waiting for Godot* but the text of this, and Beckett's other work, will be readily and cheaply available to her or him through any good bookshop. If our interest is with paint applied to canvas, photography can provide at best a very inadequate substitute. It is likely that other works by Titian will be scattered in collections around the world. The loss and destruction of works of art in national and private collections – whether through fire, theft or malicious attack – is a constant sad reminder that sometimes nothing can, at the final count, replace an original art object. Beckett's *Waiting for Godot* will never be lost, but armed conflict, whether in the Middle East or in central Europe, can result in total destruction of artworks for which no replicas (and sometimes little in the way even of records) survive.

Engravings, phonographs and any form of print – of which there are normally more than one copy – may also be regarded in art-historical study as original objects. In fact, each photographic print or the state of an engraved plate will be physically slightly different from all the rest in the series even though the image may be identical. Moreover, it is the legitimate and worthwhile task of art historians to engage with reproductive art forms in which the very fact of multiplication and dispersal may be of the greatest interest. How are Benedikt Taschen reproductions marketed? Who buys 'Van Gogh's *Sunflowers*', and for what purpose? Why do some images get reproduced many times? The historical importance of these questions is huge and this is reflected in the careful accumulation of certain categories of so-called 'ephemera' by museums and galleries. The British Museum owns a unique collection of trade cards from the eighteenth century onwards, while the Victoria and Albert Museum has an interesting collection of posters, including the contentious Benetton posters produced in the early 1990s. The University of Sussex Library possesses a collection of ephemera gathered from the streets of Paris

by someone who happened to be there during the student uprisings of 1968 and recognized the historical significance of these spontaneous and short-lived material acts of communication. Although, of course, much less survives from earlier periods, interest is not confined to print produced since the great technological changes of the nineteenth century.

Now, and at all times in the past, artists and publics have frequently encountered works of art primarily through copies or reproductions rather than through an 'original'. The 'portrait' of Socrates that was known throughout the ancient world and from which the philosopher has been recognized and identified ever since is a copy after an original executed hundreds of years after his death. The art of Renaissance Italy was known to northern artists and craftsmen first and foremost through engraving. Since the development of photography and cheap printing methods it is very usual for us to encounter an original only after having become very familiar with its photographic reproduction. For art historians, then, the dissemination of imagery through mass reproduction, its transformations and transmutations, are as important as paying attention to the original. One might well ask which is more 'real', the Venus de' Medici in the Vatican or the many copies to be found throughout the gardens of Europe and North America from the eighteenth century to the present day. The study of film as a medium involves, inevitably, an experience of viewing that has been, and will continue to be, replicated anywhere in the world. The analysis of narrative and imagery will not be determined by whether you see the film in Tokyo or Toulouse but it may, of course, be affected by the event of the showing and the collective experience of being part of an audience.

The data that is available on works of art and cultural objects is constantly being updated, revised and reconsidered. The latest attribution is not necessarily the correct one, and it would be too much to expect someone starting out as an art historian to be fully cognizant with all the articles on 'a recently discovered' or 'a newly attributed ...' in the specialist Art History journals. What everyone can recognize, beginner and established scholar alike, is that all scholarly writing is cumulative and that what we call facts (dates, information on media and patrons, definitions of subject-matter and function, location) are not innocent of meaning. They are packaged in an act of communication (in a book or an article or a lecture) and so become part of an argument. How these arguments shift and change, and what interest and investment underpins them, is called historiography. This is

literally the history of Art History. How we come at that, too, is determined by how we are positioned in our own time.

Recently there has been a great deal of interest in studies of the historical and metaphorical conceptualization of the body, whether in visual art or in literature. (See, for example, K. Adler and M. Pointon, eds, *The Body Imaged: the Human Body and Visual Culture since the Renaissance*, Cambridge, 1993 and N. Kampen, ed., *Sexuality in Ancient Art*, Cambridge, 1996.) These studies challenge the idea of a sexually fixed biological body that is always the same. They set out to explore the way different individuals and groups in the past – and the present – have envisaged parts of the body, interior and exterior, have constructed ideas of a body as something that works coherently (while made of different bits) and that images ideological concepts like the State or Revolution. This has happened partly as a result of an intellectual trend of the 1960s called structuralism (which encouraged scholars to look for common elements and motifs in diverse chronological periods), partly as a result of increasing interest among scholars in the human and biological sciences in the role of gender as a cultural determinant. Our sex is biological but how we understand and articulate our difference one from another is a question of gender. A further contributory factor to these changing academic interests is undoubtedly the phenomenon known as postmodernism, which recognizes a loss of established patterns of meaning in the late twentieth century and which is concerned with fragmentation as central to human subjectivity. The point is that scholarly and academic areas of study do not just evolve; they are always a result of some collective (even if unrecognized) concern in the present.

Art historians, then, whatever their approach or method, take a critical view of the way that data is presented and published. Works that may be out of date in terms of the data they impart may still be of interest as historiography. Crowe and Cavalcaselle's massive book on the Italian Renaissance may appear definitive but it is important to realize that it was written at a time when incomplete information was available about the material condition of works of art and about their documentary history, and it is, therefore, less than factually reliable even though we may admire it as a milestone in art criticism. Similarly we may read Roger Fry on Cézanne because he writes beautifully and has marvellous insights into drawings and paintings made by Cézanne. At the same time we need to ask ourselves, in view of the fact that his book was written in 1927, whether Fry might not have revised his view had he been aware of

some of the paintings and drawings of Cézanne which were then unknown or had he had the benefit, for example, of recent discussion about the relationship between Cézanne and the seventeenth-century French artist Poussin.

In other contexts art historians might well be avidly reading Crowe and Cavalcaselle and Roger Fry, while at the same time trying to locate their descendants and read their manuscripts, diaries and letters in the hope of discovering more about how these connoisseurs and writers worked. One branch of Art History is concerned with changes in taste and in how the history of art is constructed as a sequence of conceptualizations – or linked ideas and interpretations – about the past. How these early art historians worked, what methods they evolved, on what bases they made their judgements is of profound interest, therefore, to art historians for itself and for an awareness of why we think about certain kinds of art the way we do now.

A historiographer looks at texts not for what they tell us about particular artists, their lives and their works, but in order to recognize and analyse the historical and theoretical premises on which the writer based his or her discussion. Historiography is more than the kind of concern with artists' writings as an extension of their art or the art of their time (Sir Joshua Reynolds's *Discourses*, for example, or Diderot's Salon criticism) that is often termed Art Theory in course material. Unlike Art Theory, historiography examines the principles underlying the construction of the discipline and thus helps us to be more discerning about the kinds of argument being marshalled in support of any given body of material and enables us to recognize what sort of Art History is being written and why. Many of the assumptions upon which current expositions of the history of art are based derive, as I have suggested, from celebrated texts written and published in the eighteenth century or earlier. They are, almost without exception, based on Western traditions of art which are understood to originate in Greece and Rome and exclude, therefore, the very different premises upon which the art of China, Japan, Latin America, the Indian sub-continent, Oceania or Africa is based.

An increasing awareness of these issues is resulting slowly in a rethinking of the categories of period and style definition that used to dominate. Likewise, attention is being paid to the transmission of ideas and ways of making things look a certain way (style) across cultural boundaries. The concept of cultural hybridity – that is, the amalgamation of bits of different cultures into something new – has enabled art historians and anthropologists to find a framework for

studying, for example, how the impact of Western cultural artefacts upon an African tribal society results in art forms which do not need to be understood as debased but can be understood in terms of how the Coca Cola can may be assimilated and re-invented in a different cultural context. Likewise there has been much effort to redress the culpable and destructive disregard of the Western nations for the art of those areas they colonized; there is, for example a commitment to the study of aboriginal art in Australian centres of learning.

* * *

Because the discovery and authentication of works of art has played such an important part in traditional Art History, and because the first writers of Art History sought to demonstrate that the art of their time was more successful than that of previous ages, there has been a tendency for the art historian to be preoccupied with development and 'progress', with what one artist bequeaths to the next in the way of subject or style. Thus much of the art of the past has been seen in terms of one artist climbing, as it were, on to the back of his predecessor. This view of the art of the past (or indeed that of the present) as a great chain in which A leads to B which leads to C (or Cimabue leads to Giotto and Giotto leads to Masaccio) implies that art in some ways gets 'better'. Moreover, there are artists who do not contribute to an easily recognizable development of this kind and who, therefore, get left out. Botticelli did not fit into the developmental principle devised by the Renaissance historian Vasari, and consequently his work was neglected and almost totally unknown to generation after generation until, as I have pointed out, he was 'rediscovered' in the nineteenth century.

Art History has concentrated on great and acknowledged (mainly male) masters of the past. Certainly it is useful, and indeed it is essential, for us to know as much as possible about artists who have produced large quantities of innovative and outstanding work like Michelangelo or Delacroix, but the disadvantage of the great master approach is that it tends to isolate the artist from the context of ideas, beliefs, events and conditions within which he or she lived and worked, as well as from the company of other artists. It may well be that in some instances the identity of a group may be obscured by the treatment of an individual. Thus an overall view in which the artist is seen in relation to his or her period is the price that is sometimes paid for detailed documentation about the work. Such an

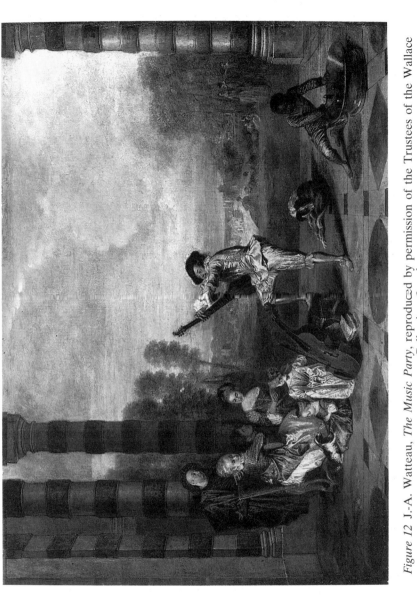

challenged: its assumptions, its methods, its objects of enquiry, since all of these have been constructed within a patriachal society.

The notion that feminist Art History is only concerned with women artists or images of women is a misapprehension. Feminist Art History has drawn on work in Women's Studies (which as an interdisciplinary field brings together many of the humanities disciplines) to examine gender as a shaping and defining category in cultural formations. Thus, for example, in architectural history a scholar might ask how different parts of a house were disposed according to separate gender-specific functions – women's quarters, men's spaces – as well as according to a hierarchy of class – servants below stairs, family above. Here gender can be understood as the organizing determinant in the matter of social space. Questions like this involve a consideration of power, and so analysis of gender might accompany, or be informed by, a discussion of race. In both cases it is the category of difference – those distinctive characteristics that empower one group while defining the other as in a dependent relationship – that works to establish what are understood as certainties by the societies that consume works of art. Cultural forms – paintings, sculpture, furniture, and so on – through the way in which they make available sets of associations or images in specific contexts, can establish those differences which are not biological but are socially produced and reproduced. Thus work on Renaissance *cassoni* or marriage-chests has examined the imagery of violence that appears on decorated items of furniture (Figure 13), containers for the bride's dowry, in relation to Renaissance legal and domestic requirements with regard to the social relations of marriage.

* * *

Architectural historians are concerned with questions such as how the style of buildings changes, what the relationship is between the appearance of a building and its function, what part is played by sculpture and other decorative devices, how the final building evolved from its early plans, how the building relates to its environment, who built it and why, who paid for it, who used it, what it feels like as a three-dimensional work of art, and many similar questions. The object of an architectural historian's interest may range from a grand Baroque palace like Blenheim in Oxfordshire or a cathedral, to the characteristic dwellings of cotton-workers or miners in Lancashire or Yorkshire. Most architectural historians begin as art historians but, as with Design History, the discipline of Architectural History soon becomes very specialized, with its own technical vocabulary and its

approach also assumes some kind of simple link between the artist as a human being and the work that we have on view.

In the 1970s a debate developed about what elements of language, cognition and unconscious and subconscious dynamics are at work in the complex and only partially understood relationship between any human subject and an experience triggered by the imaginative act of another human subject. This debate drew on already existing discussions in linguistics, philosophy, anthropology, film and literature. The consideration of these kinds of issue is given the general label 'critical theory', though many different things are encompassed by this. Theory seeks an explanation of the why and how of recognized forms of visual experience and collective types of historical explanation. It is now intrinsic to most serious writing on the history of art and artefacts though those who practise a theorized Art History are still all too frequently the objects of vilification by a deeply conservative heritage lobby, for whom Art History remains the apparently unproblematic assemblage of facts. To give a simple example, Giotto's frescos in Assisi are based on the life of St Francis. A historical explanation for this would be something to do with the power of the Franciscan order and the need to give an illiterate audience a visual equivalent to sermons they would hear from the pulpit. An art historian working on Giotto might address how the artist composed his compartments, which subjects he selected and what pigments he used. An art historian interested in theory would, however, ask questions about narrativity itself, that is about what happens in story-telling, how the things which are *not* said may be as powerful in communicating a series of ideas as the things which *are* said, how readers or viewers make sense of a whole from a series of partial clues that make up a story, why and how human subjects in the West at different times desire stories to be told, what the structural relationship between the beginning, middle and end of the story might be, and what different stories have in common with one another.

Similar debates have taken place about what constitutes history, debates which echo and are informed by discussions in contingent disciplines. Attention is paid not only to things that are known to have happened but to evidence of desires and aspirations. Marxist historical analysis in the 1960s was of major importance in bringing about changes in art-historical practice. Many art historians who have never read a word of Marx and who would certainly not describe themselves as Marxist have, whether knowingly or not, taken class, labour and the economic structure of capitalist society into account

as determinants in the production of art, whether it be in the Renaissance or in the present day. On the one hand popular traditions, 'low' art forms and mass communication now receive serious attention from art historians: photo-journalism, video art, youth culture and graffiti are among topics that have been researched by scholars in the past decade (see, for example M. Cooper and H. Chalfant, *Subway Art*, Thames and Hudson, 1995). On the other hand more attention has been paid to the reception of artworks in their own time and to studying how a visual image can provide a ground for the making of meanings within a given society, meanings that may or may not have anything to do with the apparent subject-matter or narrative of the image. For the social history of art (as this sort of enquiry is often called) a *fête champêtre*, or a courtly picnic scene by a Venetian sixteenth-century painter, or by a French eighteenth-century painter (Figure 12), may be a rural idyll of upper-class love and pleasure but may, at one level, be understood also to represent and therefore re-enforce the power relations between women and men and between different classes within the society which produced the image. The countryside is not neutral but carries with it, by implication, its absent counterpart, the presence of the city and the court. It goes without saying that the discrediting of organized state Marxism by regimes in Eastern Europe during the early 1990s does not devalue the inspiration that scholars have drawn from the theoretical writings of Marx who was one of the great historical thinkers of his era.

Feminist Art History has brought to light hitherto neglected or unknown women artists and has encouraged debate about women's art practice in our own day. Do women get a fair share of exhibition time and space? Do they get serious treatment from the critics? Are there areas of human experience that are peculiar to either sex and justify a separatist approach to the production and display of art? It is no longer possible to view Mary Cassatt as an appendage to her friend, Edgar Degas, or to see Artemesia Gentileschi as merely an arm of her father, Orazio Gentileschi. Moreover, the analysis of images of women and men, whether in advertisements or in paintings that are time-honoured and familiar landmarks in the canon, has been revolutionized by feminist discussion. Equally, genres such as flower painting and media like ceramics and embroidery, which have traditionally been the province of women, now receive more sustained attention and a critical historical appraisal that places them in relation to other forms of artistic production. For feminist art historians, the entire edifice of Art History is to be

considering questions of patronage: which artists, architects, gardeners were chosen, what they made, how much they were paid, where the money to pay them came from, how they were paid and so on. By piecing together all the available information and analysing it in the light of theories of consumption and production, we may establish an account of that elusive aspect of the historical which goes by the name of 'taste'.

The same principle applies in the study of, say, a new town development of the 1960s or a garden city of the 1950s and in the study of ecclesiastical buildings, the appearance of which is subject to constant change according to shifts in theological thinking, developments in techniques of building and the vicissitudes of government and governing policy. Take, for example, the church of the Gesu Nuovo in Naples, which, built between 1584 and 1601, on to the façade of a Renaissance palace, contains a rich treasure of frescos and ecclesiastical objects and which has an interesting political, theological and social history. In order to appreciate all this fully, the building must be studied as though it were a living organism. In the case of a new town, employment and leisure patterns, use, wear and tear, ownership and social mobility would all need to be taken into account.

* * *

It is in the study of taste and patronage that the art historian and the social historian most frequently interact. One of the art historian's most difficult tasks is to account for the popularity of certain subjects, styles and artists at certain periods. To achieve this, both reliable factual data (often economic in character) and an ability to interpret imaginative acts of communication are needed. One might, in fact, very well argue that the distinction between the historian and the art historian is a false one. But if the historian is not a drudge neither is the art historian an aesthete who depends on the historian to make the discipline of Art History academically respectable. Art historians need to do their own research and, while the two disciplines are complementary, they are not interdependent. Historians can learn much about art practices, conventions of image-making, communication and ideology from Art History; at the same time Art History has more to do than simply see history as a background to art.

The acts (or artworks) we have been discussing may be used as evidence by historians, though this, as we shall see, creates its own

problems. But art historians, as we discovered right at the beginning of this chapter, cannot just be art appreciaters; they have to be in a position to unravel and evaluate the meaning of a work of art in its historical context. Only by doing their own historical research can art historians begin to understand how a painting looked to people who saw it at the time it was painted or to the patron who commissioned it.

The historian of taste or fashion also faces the problem of working in several media. The greatest private patrons of the past, those who were responsible for commissioning so many of the paintings that now hang on the walls of our national galleries (thanks to wars, revolutions and economic difficulties in Europe) bestowed their beneficence and their orders not only on painters but also on craftsmen, musicians and poets. In discussing individual patrons we do, of course, have to tackle the concept of beneficence rather than taking it as a given. The idea of the disinterested collector concerned only to enhance the cultural heritage by a large donation to a public institution is prominent in Western mythology. Donations by art-collectors ensure for them a place in history. Robert Lehman, who left a substantial collection of European painting and decorative arts to the Metropolitan Museum of Art in New York, was described in extravagant terms that construct him as companion, equal and help-mate to the artist of genius. The visitor is introduced to his collection (which is housed in its own named wing and has its own catalogue) thus:

> What you are about to see is the culmination and product of the response of a civilized and imaginative man to the impulse, the creativity and, in some cases, the desperation of the artist to make the world, its beauty and meaning, come true. Above all else Robert Lehman cared for quality and beauty, however expressed. His continuous search for it together with his humanity produced this collection and made him unique.
>
> (George Szabo, *The Robert Lehman Collection: A Guide*, New York: The Metropolitan Museum of Art, 1975, foreword)

Gifts such as Robert Lehman's are generous acts indeed and serve to enhance the access of people who do not buy and own works of art to visual culture from the past. At the same time, as professional art historians, we must make ourselves aware of the forces of financial investment – and the powerful need of one country to possess parts of other nations – that also underpin the activities of those who care for quality and beauty. We need, moreover, to be aware

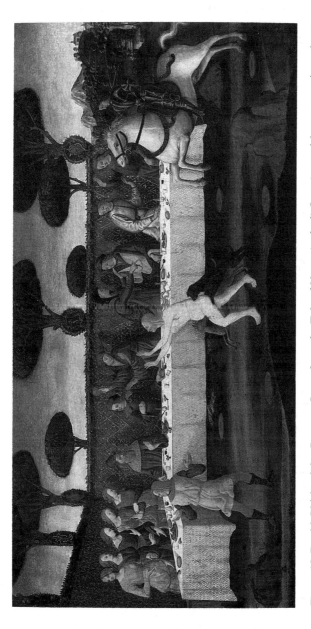

Figure 13 David Ghirlandaio, *Banquet Scene from the Tale of Nastagio degli Onesti*, panel from a marriage chest, The John G. Johnson Collection Philadelphia Museum of Art

own methodologies. Indeed, approaches to Architectural History are as various as those to Art History, and the capacity of architecture to arouse strong feelings has been amply demonstrated in recent years in Britain, where the heir to the throne has taken a special interest in the relationship between past architecture and present-day practice. Nevertheless, the association between Architectural History and Art History is a firm and generally productive one. After all, buildings are the most universally experienced part of our environment, although the destruction of fine buildings from the recent as well as from the remote past in every town and village is depressing evidence of our inability to notice and understand what is around us in time to halt the inexorable 'progress' of the developer. Many architects have also been painters and sculptors; it is unwise, for example, in studying Michelangelo's painting and sculpture to omit his activities as an architect. Moreover, architectural design, planning and the development of the environment necessitate considerations of power, politics, government, patronage and ways of living that also have far-reaching implications for historians of all varieties.

The great house or planned public building, with its combination of architecture, landscape and decorative art (as well as the paintings hung in its rooms), has frequently been seen as the total expression of a single philosophical, political and aesthetic point of view. For example, a house like Chiswick House near London attracts the architectural historian and the art historian. The paintings, sculpture and interior detail in this house might be the subject of individual study by art historians, and the structure of the house might command the attention of the architectural historian. Landscape gardening is a subject of special interest to the student of the eighteenth century, and the grounds of Chiswick would, therefore, be considered as visual works of art in their own right. If we approach the study of a great house with this largeness of vision there is a chance that we shall see 'Parts answ'ring parts . . . slide into a whole', as the poet Alexander Pope expressed it when writing his epistle 'On the Use of Riches' to his patron, the architect and owner of the house, the Earl of Burlington.

On the other hand, a house and its estate may be the result of diverse building and collecting activities by different owners at different times in the past. If so, it will demand a slightly different approach if we are to ascertain what was created when. But the point about studying the house and all that goes with it in its totality still remains. When we look at the complex growth of an estate, whether it be within one man's lifetime or over many generations, we are

of the implications of the movement of works of art across national and cultural boundaries, whether between East and West (in the sense both of the Orient and Occident and of the former Communist bloc and the Western markets) or between the so-called developed and the so-called undeveloped nations.

We have been talking as though the history of taste is solely concerned with aristocratic patrons like the Habsburgs, or those possessed of gigantic wealth like Lehman. Mass culture, as we have remarked, is also an area of study proper to the art historian. This is evident when we look at the development of cheap methods of reproduction (like lithography), when we examine the response of the public to works of art after the inauguration of regular open exhibitions in the nineteenth century or the way in which the poster became such an important medium for artists in Germany in the 1930s, or when we look at how fashion and apparel have not only been an area of creativity in their own right since records began but have also provided inspiration to artists working in the so called 'high art' genres. We might cite Gainsborough's interest in fashionable dress of his day or Man Ray's preoccupation with fashion garments.

* * *

There exists no single line of enquiry we can label Art History. This much will have become evident. Indeed, the reader may well feel that we have evaded the basic question: what is art? Part of the purpose of this book is to show that there is no single answer to that deceptively simple question. The fact is that once we apply ourselves to the question of what art is we become philosophers rather than art historians. Philosophy, and particularly that branch of philosophy which deals with aesthetics, has made a contribution to the discipline of Art History. The art historian's role has always been, however, to elucidate the work of art, not least contemporary art, relating to its socio-historical context rather than raising it out of time and defining it or 'appreciating' it as a disembodied work of genius. Anything that a body, past or present, regards as art should be treated as art.

The question of what is a legitimate line of enquiry remains a contentious one. If design historians are discussing the evolution of the characteristically shaped and packaged food-mixer or beer can, what should be the range of art historians? Should they confine themselves to architecture – in which case should everything from

monasteries to cooling towers be included – easel painting, sculpture, fresco and the decorative arts like tapestries and ceramics? Or should they use their expertise upon other sorts of visual communication: advertisements, film, Tretchikov and mass-produced artworks, clothing and the more ephemeral aspects of our visual experience like sports events, or those in which no individual or group seems to have had control, like the cityscape we see around us every day? Part of the answer lies, as has been indicated earlier in this chapter, in whether or not quality is an issue at stake. But even if art historians agree, say, that it is recognized French painting that is the object of study (for example, that which has, through whatever means, withstood the so-called test of time) they may still disagree about whether these paintings should be viewed as discursive (telling us things, conveying ideas) or sensuous (expressing feeling and transmitting materiality). What is vital in all this is that art historians should, whatever their agenda, know and be prepared to communicate what that agenda is and how they propose to deal with it.

One manifestation of the development of Art History as a discipline during the second half of the twentieth century is the ever-widening range of material which the art historian is expected to discuss and interpret. Another is the lively debate about how this material ought to be used by art historians and by those specializing in other disciplines like Sociology, Psychology, History and Anthropology. Is a tribal mask a wonderfully crafted object whose aesthetic impact demands that it be displayed on a wall, or is it a part of a complex culture, offering evidence of ritual practices and patterns of belief? Anthropologists, because of the nature of their work with cultures that are not primarily literate, usually have respect for non-verbal forms of communication. But the reverse is often true in other areas of the social sciences where (surprisingly to my mind) visual texts are often treated in an impressionistic and ahistorical way which would never be the case with written documents.

From psychologists we have learnt, through the valuable mediating contribution of scholars like Sir Ernst Gombrich, how to understand more of the processes that make up what we call perception; in other words, how we see things and what part our seeing and learning and knowing plays in the making and reading of pictorial images. With the help of psychology, archaeology and chemistry, it is possible for us to begin to know a little more about what colour has meant in people's attempts to communicate pictorially through the ages. Demographic historians (who study population growth and the patterns of change in life-expectancy, the distribution of the population by age and sex, etc.)

have enabled art historians to ground their knowledge of medieval culture more firmly. We need to know about demography in order to know, for example, what the attitudes of parents in earlier ages were towards their offspring. And we need to know about these attitudes in order to understand forms of representation like dynastic family portraits or images of wives or children. Legal historians can offer art historians a source of information about property (whether land or goods and chattels) which informs work on both the fine and the decorative arts. The list could go on, serving to demonstrate the inter-dependency of the humanities disciplines as well as the breadth of Art History.

Some art historians have drawn on Freudian and post-Freudian psychoanalytical techniques in an attempt to reach a greater degree of understanding of the meanings of works of art and how we 'read' them. Whilst there are obvious dangers in imagining that an artist, long dead, can be, as it were, resurrected for the analyst's couch, works of art themselves, supported by reliable biographical data, can be recognized as having latent as well as manifest meanings. Scenes of beheading (for instance, John the Baptist) may thus be interpreted, using Freud's case histories, as narratives of castration. Representations of women may be analysed according to theories of fetishization.

Such a method, critics may object, is transhistorical – it applies a theory devised in late nineteenth-century Vienna to a body of material produced in a different time and place and interpreted by a scholar in yet a third time and place. It also treats the individual rather than society. The proponents of this method argue that it is Freud's theory (rather than his clinical method) that is drawn upon, that this theory provides one of the richest ways of approaching cultural experience as structured according to laws (the laws of representation, narrative, mythology, fantasy and so on), thereby enabling scholars to move beyond the idea that in commenting upon a representation of something they are commenting on the thing itself. An image of an eagle is not the same as an eagle. It also permits scholars to move outside the bounds of the commonsensical approach to culture which proposes that all is clear and evident and there is no meaning that is not already obvious. This denial of ideology has been particularly tenacious in Art History by contrast, say, to Language and Literature.

Whilst Freud and Lacan (in re-interpreting Freud) have both been accused of misogyny, their work has been extensively used by feminist art historians, thus pointing up the need to distinguish between these

authors and any general view of their work on the one hand, and the use that may be made of certain themes on the other. In the case of Freud, his insistence on sexual difference has been a mainspring for art historians seeking to account for visual forms in patriarchal society. In the case of Lacan, his argument about the construction of gendered identity through culture – as well as the role of vision in that construction – has proved particularly inspirational.

Psychologists have helped to demonstrate the superior power of the visual image over the written or verbal description in arousing immediate and strong responses. This goes some way towards explaining why the visual arts (especially painting) have always had an important propaganda value. Art as propaganda has always been as much the province of the social historian as of the art historian, but collaboration can be very productive. A portrait of a ruler may have been intended by its subject as a piece of propaganda, but it is still the result of an imaginative act on the part of the artist. The art historian who ignores historical facts does so at his or her peril. Goya's painting *An Episode of 3 May 1808: The Execution of the Rebels in Madrid* demands to be read within the context of the historical event which provoked the picture and which is cited in the title. Whether or not Goya personally witnessed this event (extremely unlikely) is much less important than the ways in which what he represented constituted a response to a common cultural perception of what did, or could, happen.

* * *

Pictorial documents are very seductive; they can so easily appear to enliven the historian's text. How dangerous it is, however, for the historian to assume that pictures from a given period can provide an authentic record of how life was lived or even details such as what people wore! We know, for example, that in the eighteenth century Gainsborough painted a number of sitters dressed in the seventeenth-century fancy 'Van Dyck'-style clothes. It is thought that he kept a collection of such clothes in his studio for his fashionable sitters to pose in, although he usually preferred them to wear their own clothes. Dutch seventeenth-century portraits sometimes contained deceased, as well as living, members of one family. Genre paintings from the same era are often thought to record faithfully how people lived at that time. But we now know that Jan Steen's *School for Boys and Girls* (National Gallery of Scotland) is an allegory of the school of life in which different parts of the painting

represent different human vices or virtues. It may also bear some resemblance to the appearance of a Dutch schoolroom in the seventeenth century, but, since the intention of the artist was not to provide a mirror-image of what he observed but a commentary on life, it would perhaps be dangerous to assume this to be the case. Even with what we might regard as documentary reportage we find convention at work. In photography, and in Realist art, the reality effect is the result of a carefully produced organization. It has been demonstrated, for example, that a journal like the *Illustrated London News*, which presented itself as documentary, in fact used and re-used the same engraving, introducing rioting crowds or a royal procession into a standard urban background as the current situation demanded.

Paintings can provide factual information of the sort the historian is seeking. Joseph Wright of Derby depicted in great detail an eighteenth-century air pump in his painting *An Experiment with an Air Pump* (Figure 14). But in using the contents of paintings like this as historical evidence we must employ much discretion and caution, checking all other known visual and verbal accounts and making sure we understand as far as possible the intellectual and imaginative climate within which the artist worked, as well as the historical and ideological situation of which the incident depicted is a part.

The same painting may be analysed by an art historian using a method associated with structuralism, seeking to identify the deep structures within a work independent of its apparent narration. The components of the image are thus seen as signs; they carry meanings which may be independent of or even in contradiction to the apparent subject of the painting. In this particular work there are ten figures, but most of these figures have at least one eye in shadow. A discussion of this characteristic, possibly relating it to hands and spherical containers, might lead to a discussion of this painting (whose subject-matter is science and history) as a discourse upon blindness and sight. Semiology (the science of signs) is at a more highly developed stage in relation to language-based art forms than in Art History, but it is, nevertheless, a theory and a practice that has directly or indirectly made an impact on the study of paintings and is widely encountered in film and media studies.

There are many close ties between Art History and Literary History too. The friendships that are known to have existed between artists, writers and musicians (Cézanne and Zola, Reynolds and Johnson, Titian and Ariosto, Delacroix and Chopin) should have ensured that art historians are keenly aware of what each discipline

Figure 14 Joseph Wright of Derby, *An Experiment with an Air Pump*, reproduced by courtesy of the Trustees. The National Gallery. London

can offer. There are also the poet-painters or painter-poets like William Blake whose work demands to be considered as a whole. The study of paintings which treat subjects from literature and, connected with this, the field of book illustration, can be extremely rewarding for art historians, especially if one literary text is followed through a variety of pictorial interpretations. It would be interesting to trace, for example, narrative cycles based on Ariosto's stories in the Renaissance period in Italy or paintings which derive from a reading of Malory's *Morte d'Arthur* in England in the nineteenth century. But question such as 'How can the artist transfer to the static medium of paint a story which is expressed through a time sequence in literature?' require a theoretical basis for exploration. The relative powers of painting and poetry have been discussed since antiquity, and academic journals like *Word and Image*, *Representations* and *Paragone* are testimony to this abiding interest. A clear understanding of the characteristics and limitations of different media – of linguistics, line and colour – and an awareness of the functions of painting and literature is essential for this kind of work.

Reading is, like looking, historically located. Art historians ask questions about the relationship between words introduced into pictures (as in medieval manuscript illumination or the collages of Braque and Picasso, where pieces of newsprint become part of the image) and the spoken as opposed to the written word. The shifts and associations, differences and complementary characteristics between written and spoken and between written and imaged depend on a complex set of historical conditions at any given moment in time. Recovering these relationships may lead to a radical re-appraisal of the meanings of a given image.

From what I have said in this chapter it will have become evident that there is no single route and no single object for the art historian. The skills that are needed are many, but so are the intellectual rewards. Like any other discipline (the word is apt) Art History demands commitment, dedication and lots of hard work: looking, reading, asking, searching. Once you start you seldom want to stop. The following chapters are intended to help those who have made a start to proceed on their way.

3 How art historians work

An art historian is a person who is engaged in exploring and analysing the construction and form of artefacts, and their functions, both practical and symbolic, in the time they were produced. So, what do art historians actually do in the world of work? At the end of this chapter you will find a discussion of the kinds of career opportunities that have traditionally been available to students graduating with good Honours degrees in History of Art. Although these are many and varied, it is still the case that a degree in History of Art is the major prerequisite for entry into the professional world of art galleries and museums. As a profession art historians tend to group themselves into those who work in museums and galleries and those who teach the subject. The division – if taken too literally – is unfortunate and misleading. It is essential for those working in museums to understand about management of public services as well as about the conservation and insurance of works of art in their care. But they are also responsible for researching and cataloguing their collections, providing a public service by organizing exhibitions, answering enquiries, and other, similar activities that are not normally part of the working lives of teaching art historians (that is, unless they are attached to a gallery education department).

The appropriate training for museum specialists is a contentious matter; in recent years increasing emphasis has been laid upon the business-management aspects of the profession as opposed to those demanding a historical knowledge and a sense of the dialectical (the argument-centred) nature of historical evidence. The recently established Museums' Training Institute, set up to monitor 'industrial standards' in the area of curatorship and museum management now offers validation to postgraduate vocational courses. Information about such courses is available from the Museums' Association (42 Clerkenwell Close, London EC1) or from the CRAC directory

of higher education courses available in any good public library. As with so many aspects of education and training, curatorial training has been the target of government directed intervention with the result that some institutions require students to take HNVQs (Higher National Vocational Qualifications) alongside their diploma or master's degree. The extent to which a course offers a 'hands on' approach, emphasizes business studies and management, or seeks to develop students' intellectual range varies from course to course. This has been an area of rapid expansion and students are advised to scrutinize closely both the programme offered and the provision of teaching and supervision. The volatile situation in art gallery and museum training reflects the importance of 'heritage' as a contested arena in late twentieth-century Britain; some interest groups see the historical material of the national past and the nation's collections primarily as a market resource; others take a philosophical and long-term view of the interconnectedness of historical evidence. Under local authorities, museums and galleries are now often administered in departments along with conference facilities, sports, local parks and other amenities. It is not always fully understood that the contents of museums (usually irreplaceable and part of a coherent pattern of relations in collecting, location and preservation that is all too easily destroyed) are not like trees and shrubs or swimming-pool equipment.

Those who teach the subject may equally find themselves thinking about problems of communication, about increasing access for students, about syllabuses, library facilities, equipment, new technology, career openings and examination procedures. Wherever they are, they will certainly be struggling to maintain quality of teaching with increased class sizes. There is a lingering assumption (fostered by journalists) that art historians in museums are only (boringly) interested in objects and their material state and that academic art historians are interested only in (outlandish) ideas. These are out-of-date caricatures and any serious event or publication in the world of Art History will attract a range of well-informed professionals from museums and from educational institutions able to communicate creatively and constructively. Academic art historians make use of museum and gallery facilities for teaching and research, and museums (admittedly not frequently enough) draw on the expertise of academies on their boards of trustees, to organize guest exhibitions and to enhance their knowledge of the objects in the collections. Arrangements to permit students in universities to be taught by museum curators are not uncommon.

History of Art students can expect to do at least some of their learning, supervised or unsupervised, in art galleries and museums. Provisions are usually available (upon prior request) for small classes to take place in front of paintings. Some, like the Tate Gallery, even provide stools to enable groups to sit while they study a painting, and some organize special day events around an 'A' level syllabus or an exhibition. Patience and tolerance are prerequisites for on-site work of this kind, as art historians reap the consequences of their own success as popularizers and galleries become ever more crowded with keen viewers of paintings. The National Gallery in London has been obliged to introduce some restrictions on school parties as a consequence of its over-popularity. No one benefits if there is a queue in front of Botticelli's *Mars and Venus* (Figure 6) or if one is unable to perceive the pointillist brush-strokes of Seurat's *Une Baignade, Asnières.*

Certain educational institutions build their courses around a special relationship with a museum department (for example, Camberwell School of Art runs a BA degree in the history of print-making in which students are able to study in the British Museum Department of Prints and Drawings); other institutions (like the Universities of Glasgow, East Anglia and Manchester) have university galleries where material can be made available for classes. There are limited but worthwhile possibilities for voluntary work in many museums and galleries for students interested in careers in museums and prepared to devote a regular time each week or a part of the summer vacation to work experience. If you want to do this, a first step is usually to write to the Keeper of whatever department you think you would like to work in. The students' group of the Association of Art Historians sometimes has information about 'interim' positions available in museums and galleries (Administrator, Association of Art Historians, Cow Cross Ct, Cow Cross Street, Clerkenwell, London EC1N 6BP. Tel: 0171–490 3211; fax: 0171–490 3277.)

Writing histories of art is the common responsibility of all art historians. The research and documentation of paintings and other objects – as well as research into ideas about art and its functions, the examination of constellations of events such as exhibitions, or revolutions, or technical discoveries, and enquires into audience responses and artistic creativity – take art historians into galleries, libraries, archives and a multitude of repositories of information about societies past and present. It may take them also into the studios of artists, into film and television studios or into factories and stores. There is an orthodoxy that argues that the composition

of catalogues, whether for special exhibitions or for permanent collections, provides the foundations upon which art-historical research, writing and teaching are based. While some art historians may concentrate on interpretation or reception rather than documentation, the act of identifying an object and writing about it (even if the objective is so-called recording of facts) is already interpretative. The idea of an infrastructure of empirical research and a superstructure of theory and interpretation is a falsification and results in a failure to recognize the difficult and complex relationship between an artefact and the meanings it generates.

A specialist in another discipline, somebody who asks questions and searches for answers quite independently of any job or organization, or most significantly a practising artist, may also be engaged in art-historical activity. The architectural historian needs to learn from the construction engineer or the bricklayer or welder the properties of different materials if he or she is going to look at the man-made environment as a totality, considering where it is, who uses it, what is to be expected in the future, rather than simply viewing it as an object or series of objects to be looked at. Similarly, the art historian must ask the artist about colour and materials whether it is ancient works of art or contemporary productions that are being addressed, bearing in mind that there is a history of pigment to be taken into account. The analysis of the pigments of old paintings is a highly specialized activity conducted in laboratory conditions and requiring considerable knowledge of chemistry, but art historians cannot afford to ignore in general the actual process of making the work of art.

Frequently the only way is to try out the materials. If it is a question of why polystyrene sculpture has immediately recognizable characteristics, it is necessary to try working with that material. Similarly, there is no better way of appreciating the qualities of watercolour as a medium than actually painting with it. The purpose of the art historian in these enterprises will differ from that of the artist because the primary concern will be not with creating art but with observing the behaviour of the materials from which the artwork is made.

The principle of learning from the artist applies not only to materials but also in some cases to subject-matter. In painting, for example, the particular problems (whether visual or practical) that the artist experiences may sometimes be best understood by the art historian who is prepared humbly to put herself or himself in the artist's place. If the subject under discussion is Rembrandt's or Bonnard's depictions of children, the art historian will find it helpful

to spend some time actually trying to draw children, because only then is it possible to appreciate that children never stay still for more than a minute except when they are asleep (notice how many artists have drawn children asleep!) and that the proportions of a child's body in relation to its head are quite different from those of an adult. We may know this to be a fact, having read it in a book. It is only by trying to draw a child that we realize it.

If we are interested in the still-life paintings of Chardin or Matisse, it is well worthwhile ourselves trying to isolate or assemble a group of objects for a still life, moving round it, looking closely at it, working out how many different ways we might see it or how we could express our knowledge of the objects involved. A child, asked to draw a group of objects, looks at each one separately and draws each one independently. We may think that we are more advanced than this, but it is surprisingly difficult to see and understand the relationship of function, shape, size, colour, texture of a group of disparate objects.

Similarly, in thinking about landscape painting, it is a helpful exercise to sit down and try to draw or paint a view. The problems of organizing elements into a composition, as well as the difficulties created by curious passers-by, inquisitive cattle, the weather, telegraph poles that do not fit into the rural idyll we were intending to depict, soon become apparent. What such exercises teach us is the constructed and artificial nature of all forms of representation, not least those that we tend to name as 'realist' or 'naturalist'.

There is no prescribed method for art historians, as will have become clear from earlier chapters in this book. As with other disciplines, how the art historian works depends very much upon the nature of the material addressed and the questions posed as well as upon the method adopted. What we can do is to describe the resources most commonly used by art historians and indicate the processes of research through which many art historians will go on their way to communicating to us what we have come to know as Art History. A diagram (and a series of questions) can help us with this discussion, though the precise order in which the questions might be posed needs to remain fairly open. My artwork, for the sake of clarity, is a painting, but it could be a piece of sculpture, an oriental vase or a group of objects, or a combination of the natural and the man-made, like Stonehenge or the Statue of Liberty. Or, indeed, it might be an event like the foundation of a national museum or a policy like that of the Arts Council in any given year. Clearly the kinds of question posed would vary according to the kind

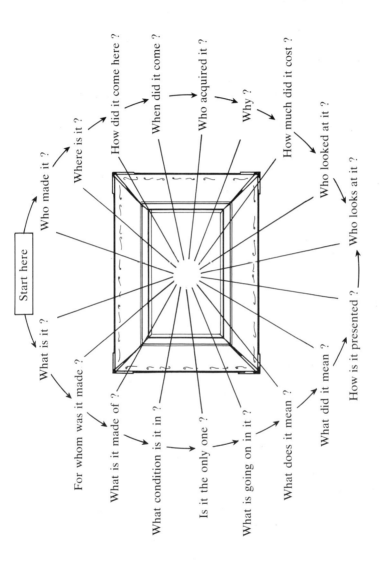

Start here

Who made it ?

Where is it ?

How did it come here ?

When did it come ?

Who acquired it ?

Why ?

How much did it cost ?

Who looked at it ?

Who looks at it ?

What is it ?

For whom was it made ?

What is it made of ?

What condition is it in ?

Is it the only one ?

What is going on in it ?

What does it mean ?

What did it mean ?

How is it presented ?

Interrogating the work of art

of object or event under discussion. My questions are based on the assumption that we are dealing with a post-medieval, Western painting; the schematic nature of this exercise conceals, of course, the complex relationships between different kinds of questions, but I have tried to show how one kind of question may lead to another.

THE PAINTING AS PHYSICAL OBJECT

One of the first questions the art historian asks him or herself is 'What am I looking at?' This may seem to be stating the obvious, but it is surprisingly easy to forget that a luminous 35 mm Kodachrome colour slide or a shiny black-and-white photograph is not the original work of art. Clearly we cannot normally take an Indian miniature or a Van Gogh home with us, and we must take advantage of modern reproductive technology but we should also be aware of the dangers inherent in using these materials.

Most art historians use photographs, even when the original work of art is to hand. Photographs are necessary for comparative purposes. We may want to compare our picture with others by the same artist or with similar works by other artists, and the only way we can do this, unless we happen to have access to a big exhibition, where we can see all the known works of the artist and lots of comparative works hung side by side (though remember even then that someone has chosen them to demonstrate his or her particular view of the artist – it will not be the only one), is to take along our photographs and hold them up alongside the painting. Or, we may want to set them alongside illustrations in books in a library in our search for visual connections. It sometimes happens that art historians find themselves trying to reconstruct the appearance of lost or destroyed works of art. In this case, photographs, engravings and any other sort of reproduction have a very special and important relevance to the study in hand.

For the twentieth century, with its emphasis on technology, the definition of a work of art is an extraordinarily complicated matter. We can no longer talk in simple terms about 'originals' and 'reproductions' since many artists are themselves using those very methods of reproduction in their work. For this and for other reasons some scholars avoid the use of the term 'work of art' altogether.

The materials from which a work of art is made are called the medium. It may seem a simple enough matter to decide what the medium of a picture is. In fact, questions of technique can be very complicated. Those concerned with conservation and restoration need

a very detailed knowledge of materials and how they behave under certain conditions. What happens to medieval altarpieces painted on wood when they are exposed to damp or heat and what happens to a contemporary work of art in mixed media (plastic, old rags, wire netting and acrylic paint, for example) with the passage of time are questions for the professional restorer. However, every art historian, student, teacher and researcher should be able to recognize the medium of the work of art. This includes not only the type of paint (oil, watercolour or gouache, acrylic, for example) but also what it is painted on. The specialist art historian working in a more advanced field may, in some cases, require a knowledge of chemistry, an ability to read a technical treatise in Latin or Italian and access to a good microscope and infra-red photographic equipment.

At the same time as he or she is considering the medium of the picture, the art historian will also be examining its condition. Paintings and other works of art have often suffered considerable damage through accident, neglect, overpainting or well-intentioned but brutal cleaning. Trying to decide how the painting looked when it was first executed requires judgement and intuition. If the picture in question is unfinished it may be necessary to consider other works by the same artist which appear to relate closely to the painting in question and then to reach a conclusion based on reasonable speculation.

Photographs tend to create the impression that everything from the most enormous canvas by Gilbert and George to the smallest seventeenth-century miniature is the same size. It is, therefore, imperative that the art historian record the dimensions of the work under consideration. If it is a framed painting the frame may be contemporary with the picture and may tell us something about the painting or the artist. The frame should not be ignored, but we must be clear whether the dimensions recorded are those of the work with or without frame, those of the paint area or those of the total canvas.

As for the frame, it sometimes happens that the artist has designed and made the frame to reflect and reinforce the statement of the painting. The Pre-Raphaelite artist William Holman Hunt arranged for the frames of many of his pictures to bear texts and emblematic designs which help the viewer to interpret the meaning of the picture. Even when we are dealing with an unframed contemporary painting, the closest scrutiny of the borders and edges is necessary in order to discover where and how the paint surface terminates.

In art galleries and sale catalogues we frequently come across the words 'attributed to' or 'school of' preceding the name of the artist. Providing answers to the questions 'Who painted the picture?' and

'When was it painted?' is probably the oldest and the most tradi-tional occupation of the art historian. At one time, art historians made attributions exclusively on grounds of style. It might be said, for example, that a drawing could not possibly be the work of Rubens because in all the other known Rubens drawings the feet of all the figures had enlarged big toes, or that a painting must be the work of Tintoretto because the trees were painted in the same manner as in all the other known pictures by this artist.

Today, with the wider application in all branches of the human-ities of technology and the increased emphasis on the history in Art History, the pure study of style tends to be given less prominence. Everyone should be able to learn to see and recognize, but there has been in the past a tendency to surround the skill of looking and knowing with mystique. The important thing is not only to see but also to understand. A friend of mine once likened the connoisseur to an expert train-spotter who did not know how a steam engine worked, who the driver or passengers were or, indeed, where the trains came from or where they were going.

Stylistic analysis can blind a viewer to the broader understanding of a painting and can result in a failure to recognize the variety and complexity of expression and meaning within the work of any one artist. Nevertheless, we should still be ready to recognize the intuitive ability of the connoisseur, the person who has spent years becoming familiar with the characteristic and subtle differences between one artist's method of execution and another's and who is able to make an attribution by eye alone. Not a few works of art have been rescued from oblivion and even from the bonfire by the timely exercise of a connoisseur's skill.

Assuming we are able to say who executed our painting, the next question is 'when?' If the artist's studio or logbook survives, or if the painting was exhibited during the artist's lifetime, we may be able to say fairly definitely when it was painted. Otherwise we have to rely on whatever details concerning the artist's life are avail-able in biographies, letters or critiques, printed or in manuscript. Comparing our picture with all known and dated works by the same artist (taking into account style, subject and technique) may also help us to decide when it was painted.

Our picture may be anonymous, or it may be associated with a group of painters rather than with an individual. In this case, the question 'where?' is as important as the question 'when?' If it can be shown that the picture was painted in a particular place at a particular time (maybe it is inscribed 'Roma, 1790' or 'Munich, 1930') and all

We are dealing here with a figurative image, that is to say it represents something we recognize from the world around us. So our analysis will concentrate on what the various parts of the painting seem to convey via this imagery. If the painting is non-figurative or abstract we would be discussing it in terms of the visual and sense-arousing qualities of pigment and colour as well as in relation to shapes and forms which relate one to another and which produce for viewers sets of associations whether material or immaterial. A figurative image is therefore a painterly sign that corresponds to something we recognize or have an idea about. A group of images – say, houses, colonnades, a child, a dog – constitute an original visual language when placed side by side or in combination. Discussion of the painting may refer to this as the field of vision, to distinguish it from a frame of reference outside the painting. In order to point out the fact that the image represents, rather than reflects, the seen world, the thing or things depicted may be termed 'the referent' of the image. Discussion of the painting as text is thus a way of analysing these signs in order more fully to comprehend the idea or ideas communicated. Understanding how and why they function as they do is as important as locating any given meanings. In other words, examining the painting as text is at one level studying how ideas are encoded. At another and interconnected level it is studying how these codes are 'read' by consumers of imagery in different conditions, places and times.

Dutch seventeenth-century paintings have long been enjoyed and admired for the apparently clear and precise way they allow us to enter into the domestic world of Holland in the seventeenth century. Such pictures can be taken as stories in paint. The girl with the beautiful profile who reads a letter – who is it from? A serene middle-aged woman is washing dishes in a back kitchen while through the door we see a tempting vista along paved passageways into cool interiors or airy courtyards inviting us into the world of the picture. At the same time, we may, without being very consciously aware of the world that the artist is describing, find ourselves immersed in contemplation of the fold of a dress, the gleam of polished tile juxtaposed with the rough texture of earthenware, or the way in which the artist has used various shades of red and gold in different parts of his painting. These qualities are in no way disconnected from the 'story' of the painting. Indeed, the 'story' is told through them but it is sometimes enriching to appreciate the making of the image without deliberate reference to its meaning. In that way we can concentrate our attention and reduce distractions.

There is, however, another equally important aspect to the painting as text. This concerns the meanings that the painting produced for audiences at the time it was executed, meanings which may have been occluded or obscured by popular or erudite readings of the image by subsequent generations. Paintings are not puzzles to be solved and in a sense nothing is 'hidden' because the evidence is always available if the appropriate modes of enquiry are brought into play. But we may not notice or be aware of the importance of a text or of the way in which we apprehend it until someone has pointed it out.

To continue with our previous example, many of the Dutch paintings to which we have already referred, are, it is now realized, far more than mere mirror reflections of everyday life in seventeenth-century Holland. They may or they may not be that – some very strict comparisons have to be made before even that point is convincing, since we have no photographic record and not a great deal of reliable documentary evidence about what Dutch seventeenth-century interiors actually looked like. But in any case, if we compare the images in some of these pictures with the appearance of objects or groups of objects in contemporary literary works, we find that they have very particular meanings.

A mirror may be depicted in a room because the artist actually saw it there. We cannot be sure about this unless he has left a precise account of how he painted the picture or someone else who knew him well and saw him painting has left a record. Equally, he may have introduced a mirror into the room because he wanted to show us what was at the other end of the room, or wished to offer an alternative view of a figure, or because he enjoyed the variation in colour values offered by the objects in the room reflected in glass, or because he was interested in a virtuoso display of his own dexterity in being able to paint reverse images.

There may also be a further reason why the artist introduced a mirror. In the seventeenth century a mirror was a sign of vanity, a worldly attribute. We know that mirrors possessed meaning in the period because whole books were published containing precise instructions about this sort of sign language and telling writers and artists the meaning of certain images in conjunction with others. So the presence of a mirror in the room may be an important clue to how the subject of the painting should be interpreted on a moral level.

If the painting we are discussing is a non-figurative work, that is to say, an abstract work, then our approach will vary slightly. We are still concerned with the way separate parts of the painting work

the other evidence of subject, style and technique points to a master working in that particular place at that particular time, the argument may be strong enough for us to use that label 'attributed to'.

As a document, the painting may not only provide us with information about the overall development of the artist but it may also tell us about the age in which it was painted. The critical response to a work of art is part of its history and, therefore, we want to know how the painting was received by those who saw it at the time it was executed and how it has been regarded by people ever since. The wider the range of opinion we consult the better: the patron, the critic, other artists, friends, relatives. Perhaps it was painted in an age from which few records have survived. Nevertheless, by reconstructing the circumstances and the social milieu in which it was created, the painting can be of inestimable value and interest as a document and, most important, we can begin to understand how beliefs and attitudes are not merely reflected in pictures but are constructed and disseminated in imagery.

THE PAINTING AS TEXT AND ITS CONSUMPTION

I have called the painting a text here not because I think it is the same as a piece of writing but in order to indicate that it may be interrogated or questioned for meanings of which some will be self-evident (this is an image of a house or a horse) and some will be located only by drawing out sets of associations (the house may be more of a castle than a cottage and suggest a relationship of power, as in Ruben's *Landscape with a View of Het Steen* which shows his own grand house) (Figure 15). Furthermore, by calling the painting a text we are indicating that not everything can be explained by reference to marks on a surface; the meanings of the painting will be determined by where, how and by whom it is consumed. For the sake of argument, let's propose Ruben's painting viewed by a group of EU farmers, a Belgian who has emigrated to the deserts of Arizona, an ecologist with an interest in history, and an expert in the mathematics of perspective. Each of these individuals would perceive a different set of meanings in this painting. Imagine the painting exhibited not in the National Gallery, London, where it now hangs, but in a deprived inner city ghetto in Chicago, a millionaire's castle in Liechtenstein, or as part of a travelling exhibition in Mexico City. Think of it hung in a room all on its own; think of it hung in a sequence of landscapes by Rubens; or think of it hung as part of a collection of images that feature artists' houses.

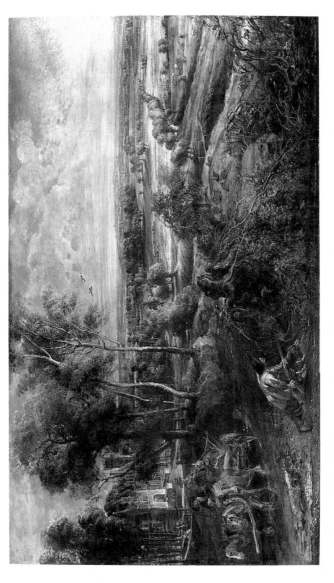

Figure 15 P. P. Rubens, *Landscape with the Castle of Het Steen*, reproduced by courtesy of the Trustees, The National Gallery, London

independently and as a whole, but we are not looking for any story to be told or explicit instructive meaning in the picture. This is not to say that the picture does not convey ideas or that it is not instructive. Simply, in an abstract painting the images are not descriptive. They may convey to us qualities such as, perhaps, brutal strength or determination of purpose or waywardness or acquiescence. They may equally well, however, have no such 'meaningfulness' and operate in relation to the viewer purely through a language of shape, line and colour. The very absence of recognizable features from the familiar external world often makes this experience all the more powerful.

Life is never simple, however, and many paintings are neither wholly representational nor wholly abstract but are a combination of the two. At all events, what is most important is for us to remain alert to what the image, or the shape of the brush-stroke, or the piece of paper stuck on the canvas contributes to the whole. To use a common expression, we need to decide how it works. To do this we need also to have some method for understanding how we respond over and above the simple 'I like it' or 'I don't like it'. Thinking about ways of doing this is to tackle methodology – the systematic and self-aware employment of method.

THE PAINTING AS POSSESSION

The idea of the artist as an eccentric genius living in isolation in a garret and painting masterpieces which are not bought by anyone and, finally, dying of starvation or tuberculosis is, for the most part, far from the truth. There has always been a strong element of fantasy and fiction in narratives of artists' lives; it is as though societies invest in the idea of unfettered creativity, making the marginalized artist a repository for the irrational which cannot be tolerated at the centre of society. These constructions – which have been extensively analysed through biography, film and other media – also set up a model of sexual difference which leaves little or no place for the woman artist although, as we now know, there have been many female practitioners in the past and there are certainly a huge number in the present. The artist is the creator and the woman is his model and/or his muse in these accounts. This is one clear illustration of how the 'facts' of a person's life come to us already mediated and interpreted.

This is not to dismiss the idea of exceptional creativity or to deny that there have, indeed, been many artists who lived out their

working lives largely unrecognized. It is merely to draw attention to the need to identify the mythologies to which the personalities of artists are central. Most artists painted pictures for people. Some commanded very high prices for their work during their lifetimes and some, like Rubens for example, led extraordinarily interesting lives in the midst of political intrigue, continental travel and court diplomacy.

The history of the painting is not only the state of the canvas (or of whatever it is made of) and all the other things we have talked of but also its physical history as a piece of property. As soon as we ask for whom it was painted we become involved in the question of patronage, finance and commerce. We need to know where the painting has been for all the years since it was executed, partly in order to be sure that it is the painting we think it is (this is especially true in the case of authenticating lost works of art) and partly because one of the responsibilities of the art historian is to chart the history of taste and consumption and try to account for that history.

Works of art represent capital investment as well as visual pleasure or nostalgic record. They circulate in markets according to the laws of supply and demand, as a consequence of fluctuations caused by war, invasion, economic changes in family fortunes, religious controversy, fiscal laws, family feuds and for myriad other reasons. What we can be sure of is that the aesthetic quality of the work (something which is not historically fixed) will only ever be one part of the reason. Paintings are bought and sold, transported across continents, used for purposes for which they were not originally intended, lost and found again. There are notable examples of paintings which have remained in the same place and have passed down from generation to generation. For the most part, however, tracing the original owner of a painting (it may have been commissioned or it may have been chosen from an artist's atelier) involves determined detective work on the part of the art historian.

We may need to consult manuscripts such as the artist's account book, his letters, contemporary documents relating to his life. We may also turn to the putative owner and find our hypothesis confirmed by the discovery that he kept a record of the commission and the purchase which is still extant in a county record office or in his family's archives.

If the canvas has not been relined and is still in its original state (that is, without having been cut down in size), it may help to look at the back of the painting to see if there are labels from dealers or exhibitions or inscriptions of any kind. Sale catalogues from long-

established dealers like Christie's or Agnew's, especially if someone at the time of the sale bothered to make notes in the margin, will furnish us, if we are lucky, with information about the fortunes of our picture through the years. The prices that pictures have fetched in the past indicate to us the relative popularity of the artist or his or her work at any one time.

It is sometimes possible for researchers to consult dealers' stock books to find out about legal owners and purchasers. Old exhibition catalogues, wills and other legal documents as well as older art-historical essays can be very informative, but great care is needed in conducting these searches, for any one painting may have been attributed to a dozen different artist in the space of a hundred years. There were, for example, an astonishing number of works by 'Raphael' and 'Mantegna' sold in London during the nineteenth century.

It is not only the artist but also the titles of paintings that change with time. People tend to give a painting in their possession the sort of title which suggests how they feel about the picture. Critics and writers often assist in this process of accretion. Thus, for example, the picture which John Constable painted and exhibited as *Landscape: Noon* is now known by everyone as *The Hay Wain*. Such changes of title are inconvenient when one is trying to trace a painting, but they can also be extremely instructive in so far as they point to the way in which people have responded to the picture in the past. Clearly, the hay wain which is crossing the pond in the foreground of Constable's picture, that is, the narrative part of the picture, was what attracted people's attention, rather than the landscape which is a much larger part of the canvas.

The artist may have painted the picture for herself or himself without regard to any patron, but it is usually the case that works of art are, to some extent, the result of a relationship between the artist and other people. It may be the general public for whom the artist is deliberately painting, it may be a particular social or political group, it may be the jury of some competitive enterprise or it may be a private individual. In all cases the relationship of the artist with his proposed audience is profoundly important both for what it tells us of the period itself and for what it tells us of the painting. It is, of course, very difficult for us to know who the artist thought of as an audience and whether he or she even thought of it at all. The medieval artist painting a mural in a church may have believed it to be his task to communicate with a great variety of people, most of them illiterate, with a range of capacity for response. He may, however, have thought of the clergy or God as his audience.

Illiteracy itself may have ensured a value placed upon oral communication unknown in our own day. Thus the conditions of viewing anything in the Middle Ages must be not only taken into account but penetrated by historical enquiry.

If the artist is painting for a particular social or political group his or her work may have elements of propaganda and we must be very sure that we understand what we are looking at. We can only adequately understand the profound revulsion expressed in the graphic work executed by the German artist Kaethe Kollwitz in terms of the audience she hoped to arouse in Germany in the 1930s.

In the eighteenth and nineteenth centuries, when the academies had immense influence and prestige, many artists painted in a way that they knew would be favourably regarded by those judging their pictures and deciding whether they should be shown in what was virtually the only public exhibition of the year. Individual critics like Diderot in France in the eighteenth century or Clement Greenberg in America in the twentieth might be said to have exerted a powerful influence on the way their generation strove to express ideas in visual form.

If the patron is a private individual questions of human relationship as well as questions of finance will occupy us. Certainly there have been extraordinary cases of patrons who have simply bought up what the artist produced without discussion or question and have thus provided consistent and invaluable material support. The French colour merchant Père Tanguy, who acquired so many Impressionist canvases in the second half of the last century in exchange for paint, often rescuing Pissarro and his friends from near-starvation, seems to have done exactly that. At the other extreme, however, are the insistent and demanding patrons with a clear idea of what they want who will continue to nag until they get it. Patronage clearly carries for the artist both constraints and advantages. The art historian collects the evidence and endeavours to gain a true picture of the situation.

The History of Art embraces such an enormous range of different aspects of our visual environment that it would be impossible to describe in one chapter how all art historians work. We have posed a series of questions about a hypothetical work of art in order to demonstrate some of the ways in which scholars work. The discussion has been limited because Art History in many of its facets challenges the very relationship between artist and object produced that is posited in much art-historical writing and which forms the basis of this exposition. To what extent, if at all, the artist's intentions are relevant to an art-historical enquiry is open to debate. For some it is the *how* of

communication rather than the *what* that matters. Nevertheless, the kinds of procedure described here are those that are still commonly met with and, in one way or another, they underlie even the most provocative and innovative challenges to the discipline.

So it would now be helpful to remind ourselves that most Art History is not conducted with one object alone, though sometimes a case-study of an individual work of art is worthwhile and helpful. Art is not created in a vacuum and most valuable art-historical studies are to a greater or lesser extent comparative. This does not mean necessarily that art historians are always comparing objects from different periods of time in order to demonstrate some kind of development; equally valuable may be a discussion that is based on theme or subject regardless of historical concurrence or chronological development. While one art historian might be concerned with a study of the development of Fernand Léger's art in the early years of this century, another might take the subject of one of his paintings, *The Card Players*, and consider what card players meant to Léger, what they meant to Cézanne and what they meant to the seventeenth-century French artist Matthieu Le Nain. Similarly, one art historian's work might be concerned with the methods used by Robert Motherwell, the contemporary American painter, whilst his colleague's work might be on the significance through the ages of Black paintings in the Western tradition.

Art historians often talk about movements. At worst, the term 'movement' in Art History is simply a lazy way of avoiding serious consideration of individual artists or of historical events. To say that Géricault was a part of 'the Romantic movement' is to place him in the nineteenth century with an amorphous mass of artists, writers and musicians generally believed to have subscribed to a vague artistic philosophy based on individuality and nature. This sort of art-historical Happy Families is not very helpful. On the other hand, the art historian is bound to ask questions about why and how one person, one group of people, one event or one work of art provokes reactions which might be classed as artistic, political or social but which will, in all probability, be all three. Here, the art historian will be exploring a 'movement'. Why Cubism should have evolved at a particular moment in history is a question which exercises the art historian and necessitates considering, not merely one or even a series of works of art but many events both national and individual and many artefacts, books, poems, paintings, sculptures.

The art historian who is interested in Cubism as a visual and historical phenomenon will need to become immersed in the period

of time when this thing happened. Anything and everything will be important: the day and even the hour when Picasso met Braque, the materials they bought, found, made and used, who their friends and acquaintances were, the places they visited and the books they read. It would be impossible to prescribe a single method for all Art History. Each scholar has to formulate his or her own questions and find means of answering them according to the needs of the subject being researched.

Students of Art History may find themselves encountering a challenge to the very idea of a movement. At a theoretical level the question of identifying and naming may be the stimulus to enquiry. It has been argued, for example, that powerful forces at work in our interpretation of historical change lead us to attribute importance to certain individual figures at the expense of groups and, furthermore, that as human subjects we require father-figures to lend legitimacy to our accounts of human productivity. History, it is argued, is not continuity but fragmentation and discontinuity. Dependent as everyone is on language, we are perpetually looking for certainties when there can be only a variety of uncertainties. In the past three decades, the clarity and forward-looking confidence of the early twentieth century have given way to a preoccupation with fragmentation, the break-up of order and the rupture of certainties. While there remain bastions within the discipline of Art History where the task is understood to be to resist all change, the more enlightened aspects of art-historical activity have responded to these global changes in possible ways of viewing the world.

The traditional methods of art-historical study derive from the accumulated cultural experience of the past but they are limited by the narrowly defined parameters of Western art, privileging oil painting over drawing, flat surfaces over three-dimensional objects and fine art over material culture. For a long time art was regarded as something decorative or external to our lives, an object that was applied or introduced deliberately into everyday surroundings, beautifying them and improving them. The residue of this 'drawing-room' attitude undoubtedly remains with us. The art historian, like the scholar in any other discipline, has constantly to examine his or her position in relation to the past and in relation to his or her own identity and identification. It is necessary to ask why this particular work has been selected for study in this particular way and to think constantly of new methods and combinations of methods for investigation. A couple of examples may help to illustrate the point.

The art historian who chose to make a detailed examination of the carved capitals of the twelfth-century church of Saint-Benoît-sur-Loire (Figure 16), where imagery has close connections with contemporary biblical, theological and genealogical writing, would surely be missing much of the 'meaning' unless he or she seriously attempted to know the everyday, human events out of which the church was constructed, what went on inside it, in what way it manifested and was part of power relations in Church and State, what part ordinary people played in the building of the church and what they contributed and still contribute to its continued existence. But they would also need to be aware of the cultural baggage they themselves brought to the task, whether it be a fascination with reading signs popularized by novels like Umberto Eco's *The Name of the Rose* or as a result of the powerful influence of early twentieth-century German art historians who wrote about medieval symbolism and allegory. We can easily ask what we think are purely academic questions about Saint-Benoît-sur-Loire because it is remote in time and, perhaps, to many also in belief and function. We need to have an awareness of the meanings that medieval monastic churches have in our own culture; timelessness, continuity, order and tranquillity might be some of them. And from here we need to ask ourselves why these qualities are of particular interest (whether acknowledged or not) to scholars and audiences at the present time.

In this chapter I have outlined the kinds of academic practice which undergraduates on History of Art degrees are likely to encounter. It is not the object of this book to offer a detailed account of careers for art historians; that would require a different book and a good deal more space. It does, however, seem fair to indicate where you might be heading if you engage in this academic activity. To start with, it is important to stress that the kinds of practice I have described in this chapter, when rigorously applied, constitute a demanding intellectual training which cultivates skills in decision-making and communication. These are 'transferable skills', that is they are skills you can take with you into the market place. Graduates in History of Art are, therefore, often well-equipped to compete for positions in business, industry and the Civil Service. History of Art graduates have been known also to go to Law School and to enter a wide range of graduate training programmes. I person-ally have taught History of Art to young women and men who have gone on to such diverse careers as senior managers in Health Authorities, the diplomatic service, advertising, or running their own

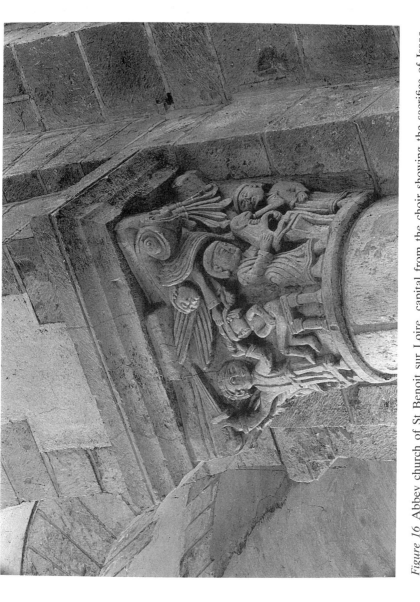

Figure 16 Abbey church of St Benoit sur Loire, capital from the choir showing the sacrifice of Isaac.
Photo: Conway Library, Courtauld Institute of Art

businesses. For those who wish to 'use' the discipline in which they have been educated, art gallery and museum work and positions in organizations like the National Art Collections Fund, the National Trust, and English Heritage or work with one of the many stately homes that now functions as a business, is very attractive. Auction houses and dealers tend to recruit people who have not only knowledge but also connections; if you want to pursue a career in this direction, it is a good idea to look at the postgraduate courses offered by Christie's and Sotheby's. Funding is extremely limited for postgraduate courses; if you get a first-class degree, there is a chance of full funding from the British Academy. There are a few bursaries around but the majority of students on taught postgraduate courses (whether full-time or part-time) pay for themselves.

Many History of Art students gravitate to the media and publishing. Teaching, especially if you are able to offer a second subject, is also an attractive possibility and for those who, having devoted three years to academic Art History, would like to return to studio practice and become an art teacher who also teaches History of Art, there are PGCE courses (for example at the Institute of Education London, and the University of Middlesex) where you can train to do just this. Whatever your chosen career, remember first that it is what you do in your years as an undergraduate (both inside *and* outside the classroom) that counts, second that competition for every job is fierce and patience and perseverance are essential, and third that whatever you go for you should expect to have to work your way in, possibly from very humble beginnings. Finally, and most importantly, consult your university career service early on – the end of your first year is not too soon – and talk to everyone you possibly can so that you build up the maximum fund of knowledge.

4 The language of Art History

The language of art itself is not traditionally speaking verbal. The caveat is necessary as many art objects (classical sculpture, illuminated manuscripts, printed and illustrated books, and modern conceptual art – as with a relief from Imperial Rome or the works of Ian Hamilton Finlay or Richard Long) may include verbal inscription as an essential ingredient. The relationship between words and images is extremely complex, partly for cultural reasons (we use words to communicate about imagery), partly because the outline shape of, say, a tow-away vehicle which is strictly speaking an icon or image can function in the place of a series of words ('If you ignore the parking restrictions in this area your car will be towed away!') (Figure 17), and partly because a letter or word is also a shape and may function as part of a composition of different shapes as well as a signifier to which is attached a particular concept. Thus the word JUG inscribed within an image field may work as three varied and related curving vertical forms and at the same time it may trigger for the literate viewer the concept of a container for liquids.

This chapter is, however, not intended to explore these questions of semantics (the science of meaning) but rather to provide some helpful commentaries on the ways in which art historians write Art History. Modern Western societies hold the printed word in high esteem; it is legal tender in a way that the spoken word is not. Scientists making discoveries must publish them before they can claim any validity for their experiments. Writing a book is still regarded in the academic world as the apogee of a scholar's career even though it may take three or four years to get a book from manuscript stage into print and the same scholar may have expressed him or herself more cogently in articles in journals or magazines or newspapers, where the delay between writing and printing is shorter and the medium is one which may reach a wider audience. One

Figure 17 Parking restriction warning sign. Photo: author

consequence of this is that when we first come to work in a subject we tend to hold the printed word in some awe and even to believe unquestioningly what we find in books. While art historians, like other scholars working in the human sciences, have begun to be more conscious of the ways in which writing determines meaning, and have begun to address the question of the authorial voice (how the position of the author *vis-à-vis* his/her subject shapes the transmission of information), it remains the case that many readers go to texts to extract 'knowledge' without thinking about the layers of language – collective and personal – within which their reading takes place.

As with other disciplines, Art History has developed metalanguages, special ways of communicating with other people in its group. Within such meta-languages certain points cannot be made or can only be made in a very roundabout and lengthy way. There are dangers that any specialized terminology may be inaccessible to a reader who has not learned it stage by stage. While there are cases of unnecessarily elaborate and obscure language in art-historical writing, it is all too easy to dismiss as jargon writings that appear difficult at first reading. Yesterday's academic obscurities are tomorrow's by-words, and criticism based on the 'jargon argument'

often originates in intellectual laziness or resistance to new ideas. Those, for example, who have accused the so-called 'New Art History' of inventing and purveying unnecessarily obscure ways of saying things fail to recognize their own meta-languages simply because they have lived with them for forty years or more and they have become an orthodoxy. New ways of thinking about things engender new ways of saying things and sometimes it takes a while both for the forms of language to settle into a recognizable clarity and for people to familiarize themselves with the terminology. There is a reputable place for populist writing which puts accessibility before all else but the place for it is not in the writing-up of serious art-historical research.

The passage below is from a 'classic' text, a canonical commentary on Cézanne from a writer who would be regarded as of an Old School of art-historical writing untouched by changes in the discipline. Notice, however, how many words and phrases (those I have placed in italics) are short-cut means used by the writer in an effort to establish what he perceives as changes in the painter's work. Many would require explanation for a reader not already familiar with art-historical terminology:

The *shut-in masses* of the houses of the terrain in the *foreground* still remind us of the *walled type of painting* of the preceding years, and especially of the 'Railway Cutting', but the lightness of the colouring is not *impressionistic*, it already contains essential characteristics of Cézanne's specific *colour treatment*. This is true also of the later pictures from this period, in which the *block-like solidity* is abandoned and the *looser construction* and lighter colouring represent a distinct approach to *impressionistic effects*: in proportion as the *contours*, the *modelling* and *chiaroscuro* are replaced by the *homogeneous impressionistic brushwork*, the *structure of the colouring*, based on small component parts, acquires a new *solidity*. In the course of Cézanne's development, a constant return to his own older *forms* and a juxtaposition of different methods of painting are characteristic, and this pecu-liarity, which makes the arrangement of his works in chronological order so difficult, is particularly frequent in the works which he produced from about 1874 to near the end of the seventies. In the famous *still-life* with the fruit-dish in the Lecomte collection, which can be dated at the end of the seventies, we have probably the first picture in which Cézanne achieves his *ultimate pictorial form*. Naturally his art undergoes plenty of changes even after

this, but we can nevertheless speak of a certain *definitiveness*, for the most important principles of *representation and form* remain from this time on unaltered.

(F. Novotny, *Paul Cézanne*, Vienna: Phaidon, 1937, pp. 18–19. Italics here, and throughout this chapter are mine.)

In Novotny's writing on Cézanne, we see the meta-language of Art History in use. A word like *chiaroscuro*, which is borrowed from Italian and used widely in European writing on the history of art, means literally 'brightdark' and is employed to describe the variations in tone from dark to light in a painting. But Novotny does not put it in italics because it is fully absorbed into the meta-language. Certain terms like 'still-life' and 'impressionistic' belong to the visual arts because they were originally coined to describe particular kinds of painting. We may also find them employed metaphorically to describe literature or music. In general, language is a vast common pool and, excepting strictly technical terminology, words are shared by the humanities disciplines. Consider, for example, these statements:

In the storm music into which the ensuring trio is incorporated, brilllantly atmospheric music whose economy ot means is again masterly, Verdi by a stroke of genius uses the humming of an off-stage chorus to represent the sound of the wind, thus anticipating Debussy by half a century. *Graphic phrases for flute and piccolo represent lightning.*

(C. Osborne, *The Complete Operas of Verdi*, London: Gollancz, 1969, p. 257)

The first works of a young poet are more frequently expressions of the intent to be a poet than exercises of a poet's powers. They are also, almost necessarily, derivative; in Keats's case the influence of Spenser is pervasive, not the homely, English, and moral Spenser, *but the cultivator of the enamelled and the musical.*

(W. Walsh, 'John Keats' in *From Blake to Byron*, Pelican Guide to English Literature, ed. B. Ford, Harmondsworth: Penguin Books, 1957, p. 224)

'Graphic' means, in dictionary terms, 'pertaining to writing', 'delineating' or 'diagramatically representing'. Yet in Osborne's description we can easily apprehend, if we listen to the music he is writing about, the quality of vividness that distinguishes the notes of the flute and the piccolo in the final act of Verdi's opera *Rigoletto*. In the second passage, 'musical' does not surprise us as an adjective since poetry is an oral medium dependent on sound, as music is. But

'enamelled' is a different matter. The writer is not, we assume, thinking of a 'vitrified coating applied to a metal surface and fired' (the dictionary definition) but wishes to convey to us, rather a decorative object in the manner, perhaps, of the Limoges enamellers who used the technique we now employ for making functional saucepans to create luxury art objects in the late Middle Ages. He therefore assumes in his writing an understanding of historical relevance and comparability. He is using 'enamelled' in a visual sense to describe words, but the sense is also that which would have been understood by Spenser writing in the sixteenth century.

Now let us look at a more recent piece of writing. Here the author tackles another very celebrated (canonical) case from the history of Western art, one which, like Cézanne's landscapes, has challenged art historians to understand and interpret the ways in which meanings are conveyed by marks on a canvas. There have been many attempts to explain what is happening in the foreground of Holbein's *Ambassadors* (Figure 18). This is one:

Across the floor of the *picture space*, or, rather, slanting across the *figurative space* above it, Holbein has painted a detailed but indecipherable smear. For the spectator standing back to the wall in a position to the right of the painting the smear is *readable* as the *anamorphic representation* of a human skull. The device is a *memento mori*, a reminder of the contingency of all that the picture represents and particularly of the mortality of the two men. While we confront the painting as a picture, the skull is *ontologically irreconcilable* with the main *illusionistic scheme*. Its *mimetic form* is perceptible only when the painting itself cannot properly be seen. Yet, once the identification is made, because the *symbol* is inscribed across or on the *illusory surface* of the painting, its signification overrides or cancels the significance of what is depicted in the painting. Like scare quotes around a sentence, it shifts the *truth value* of all that the surface contains, including all that may be seen as evidence of competence and accomplishment, and does so as a function of that same *literal surface* upon which all else is inscribed. How strange a thing to conceive; something which could only be realized if the painting were irreparably transformed – the carefully achieved illusion of its instantaneity, its *'presentness'*, damaged beyond repair by the representation of its contingency. Is it a relevant question to ask whether this damage is or is not *aesthetic ruin*? Perhaps the point is that the ruination of the aesthetic whole goes to the possibility

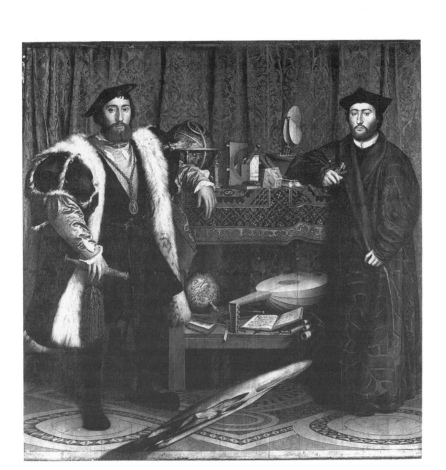

Figure 18 Hans Holbein the younger, *Jean de Dintville and Georges de Selve (The Ambassadors)*, reproduced by courtesy of the Trustees, The National Gallery, London

of a *transformed aesthetic*. The change which the skull represents is only integral to the painting, that is to say, from a *perspective* in which the status of the painting, and perhaps of pictorial representation as a whole, is cast into serious doubt.

(Charles Harrison, *Art and Language*,
Oxford: Blackwell, 1990, pp. 197–8)

Like Fritz Novotny, Charles Harrison is concerned here to prise open the experience of looking at imagery which conveys to viewers an experience of space. Harrison postulates a single unspecified spectator, standing in a certain position to view the canvas. This spectator is, it subsequently appears, himself, though the use of the term 'we' allows both the sense of a guiding interpreter and a disclaimer that it is a personal and individual experience that is being described rather than a general and universal one. What interests Harrison is how this painting demands two different ways of looking, one of which cancels out the other. It is a well-known game, and galleries where anamorphic paintings hang (paintings containing a distortion of perspective that produces a monstrous effect that can only be corrected by looking at the image from a certain angle) often provide instructions for viewing, stools to stand on, and so on.

Harrison's use of words and phrases like 'mimetic' and 'truth-value' are part of a meta-language of criticism. But what distinguishes Harrison's analysis from that of Novotny is that Harrison is not content merely to identify the visual characteristics of this form of illusionism in all their complexities, not is he concerned to trace them to a particular moment in an artist's career or to see them as manifestations of a certain period form of visual cleverness or bravado; rather, he demands to know the effect of such a feature (the introduction of an anamorphism into a conventional perspectival composition) upon the overall aesthetic.

In other words, Harrison presents as problematic and dynamic the relationship between the amamorphic skull and the area of the image in which it is depicted. This happens at the level of meaning as conveyed by the image as a whole. So, instead of having a portrait of two ambassadors in which Holbein has happened cleverly to insert an optical trick for viewers' amusement, we have a dialectic (an argument) about life and death and, simultaneously, about the creation and the destruction of ways of persuading us that we are looking at real life when we are looking at flat surfaces with marks of paint on them. So ultimately Harrison's concern is not with Holbein or

with perspective and paint (as Novotny's is with Cézanne) but with representation as a set of possibilities, laws and practices.

If we are tempted to dismiss the whole of this discussion by declaring that verbalizing about the visual arts is pointless because, had the artists believed their artistic statement could best be made in prose or verse instead of paint they would have chosen that medium, or because it is the materiality of art that is its statement and words are irrelevant, it is worth reminding ourselves that language is fundamental to our creative lives as individuals. It enables us to communicate with one another. Indeed, it has been argued that language precedes thought and that without language the conceptualization of objects is impossible. It is, moreover, the all-pervading medium of academic and cultural debate at whatever level and in whatever circumstances. Language is used by a group of people after a wrestling-match to communicate and compare their experience of the show just as it is by a group attending a private view at a London commercial gallery. Writing seriously about any subject is a creative act in itself and requires a skill and awareness that are consciously and deliberately acquired.

In previous ages, before the advent of multiple photographic reproductions in books and magazines, the greatest responsibility of the critic and art historian lay in describing the appearance of works of art and architecture. Indeed, the earliest art historians adopted a particular mode of rhetoric called ekphrasis to praise the visual through the verbal. In the nineteenth century, when newspapers began to be more widely available, page after page of the popular press was filled with verbal evocations of pictorial art for the benefit of those who could not attend exhibitions. In some cases, these descriptions possess intrinsic literary qualities which entitle them to be considered as works of art in their own right. Here, for example, is the French critic, Denis Diderot, a contemporary of Chardin, writing about one of the artist's still-life paintings. His description was for circulation in manuscript to an international circle of cultivated aristocrats rather than for the public at large.

> The one you see as you walk up the stairs is particularly worth your attention. On top of a table, the artist has placed an old Chinese porcelain vase, two biscuits, a jar of olives, a basket of fruit, two glasses half filled with wine, a Seville orange, and a meat pie.
>
> When I look at other artists' paintings, I feel I need to make myself a new pair of eyes; to see Chardin's I only need to keep those which nature gave me and use them well.

If I wanted my child to be a painter, this is the painting I should buy. 'Copy this,' I should say to him, 'copy it again.' But perhaps nature itself is not more difficult to copy.

For the porcelain vase is truly of porcelain; those olives are really separated from the eye by the water in which they float; you have only to take those biscuits and eat them, to cut and squeeze that orange, to drink that glass of wine, peel those fruits and put the knife to the pie.

Here is the man who truly understands the harmony of colours and reflections. Oh, Chardin! What you mix on your palette is not white, red or black pigment, but the very substance of things; it is the air and light itself which you take on the top of your brush and place on the canvas.

(D. Diderot, 'Salon of 1763', transl. and repr. in *Sources and Documents in the History of Art: Neoclassicism and Romanticism*, Englewood Cliffs, NJ: Prentice-Hall International Inc., 1970)

We could not see precisely what Diderot saw if we looked at the picture he describes but we can, nevertheless, learn much from writers like Diderot in the eighteenth century or Hazlitt in the nineteenth – men who acquired their linguistic skills without the aid of photographs to remind them and their readers of the appearance of objects – about the power of language to describe as well as to interpret what is seen. The original passage is in French but even in translation it retains much of its gusto and individuality. We may not wish to cultivate the declamatory tone of Diderot but there is, on the other hand, no reason why writing about art (or indeed writing about literature or biology) should not exploit all the subtleties language has to offer and give pleasure to the reader as well as enlightenment. The reason it relatively rarely does so is that it is extremely difficult to describe a work of art.

Writing of the ekphrastic kind is still to be found in contemporary writing about art. Here, for example, is a passage from a catalogue for an exhibition of the work of the American abstract expressionist Morris Louis. The difficulty of conveying in words the experience of looking at non-figurative art (the opposite, if you like, of the mimetic art addressed by Charles Harrison) impels the author into a series of metaphors. Inspired by the artist's metaphoric use of the term 'veil', he writes of the dry paint surface as liquid moving under its own momentum. He endows the static substance of the image with the capacity for physical movement as he elides his subjective response with a supposedly factual description. We have to remind

ourselves, in reading passages like this, that we are reading an inter-
pretation rather than a series of factual observations (Figure 19):

> And yet, while the staining of Louis's pictures makes them seem
> even flatter than Cubist ones, their luminism gives them also
> greater depth. In Cubist art, the symbiosis of the depicted drawing
> inside the picture and the literal drawing of its edges brings into
> the picture the compressing and tautening effect of the edges. In
> Louis's art, as in Newman's, it works in the opposite manner,
> unfolding the inside of the picture and opening it out, causing its
> pictorial space 'to leak through – or rather, to seem to leak
> through – the framing edges of the picture into the space beyond
> them'. In Louis's case, the limits of the pictorial space are defined
> (without being enclosed) by a version of that same drawing placed
> close to the framing edge of the picture, that is to say, by the
> emphatically drawn contour of the veil shape itself, and since
> the flat materiality of the surface passes through it, the effect is
> of tautness without enclosure. In the 1954 Veils, the limits of the
> veil shape are relatively fluid, thereby producing a Pollock-like
> effect of interior incident slackening in intensity toward the
> framing edges. In the bronze Veils, however, the limits are so
> firmly established as to suddenly break the intensity of the interior
> incident and create an image that is wrenched free from the
> framing edges.
> (J. Elderfield, *Morris Louis*, The Museum of Modern Art,
> New York, 6 Oct. 1986–4 Jan. 1987, Introduction; author's
> footnotes omitted)

The extent of descriptive writing in an art-historical text may
depend on the familiarity of the objects being discussed to the
assumed audience of a book. A person writing about Benin ceremo-
nial dress for a Western audience will need to go into far more detail
probably than a person writing about an Impressionist painting. But
the fact remains that there is a tradition of art-historical writing
which is predicated upon the act of describing as a supposedly
neutral process of identification and as a necessary preliminary to
all forms of analysis. Much writing on medieval art, influenced by
Erwin Panofsky, falls into this category. A listing of the features
located in an image is followed by their identification. The writer
then proceeds to an analysis of the cultural meanings of those
features or motifs. This requires the language of iconography, which
remains prevalent, especially (but by no means exclusively) in writing
about medieval art.

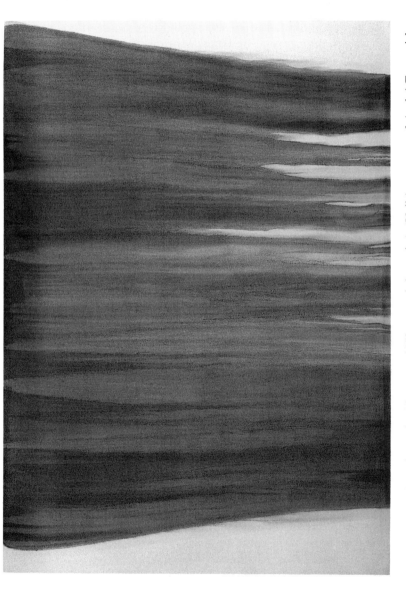

Figure 19 Morris Louis, *Monsoon*, 1959, one of the artist's 'Veils', courtesy of André Emmerich Gallery, New York

Iconography simply means the art of illustration, and iconology is the study of visual images. An icon originally meant a portrait, but the term iconography is now more broadly applied to any group of visual images that possess a specific and identifiable literary meaning. Iconographical studies are usually characterized by a wide range of linguistic and cultural references as the writer traces the modifications and shifts in the meaning and form of an image through different ages and in different countries. The language of this kind of writing can be obscure and present considerable difficulties even to an experienced reader. Writers often assume, quite unreasonably, not only a knowledge of several foreign languages but also an extremely broad cultural background. This passage is from one of Panofsky's books; it is typical of iconographical Art History in that the passage quoted occupies in the published text only a quarter of the space of one page, the other three-quarters being taken up with long and detailed footnotes in support of the assertions made in the text:

In the *Abduction of Europa* as in the *Death of Orpheus*, then, Dürer had gained access to the Antique be retracing what may be called a double detour: an Italian poet – perhaps Politian in both cases – had translated Ovid's descriptions into the linguistic and emotional vernacular of his time, and an Italian painter had visualized the two events by setting in motion the whole apparatus of Quattrocento *mise-en-scène*: satyrs, Nereids, cupids, fleeing nymphs, billowing draperies and flowing tresses. It was only after this twofold transformation that Dürer was able to appropriate the classical material. Only the landscape elements – trees and grasses, hills and buildings – are independent of Italian prototypes; and the way in which the space is filled, from beginning to end, with *tätig kleinen Dingen* is thoroughly Northern, in spite of the fact that many of those 'busy little things' are classical satyrs, she-Pans and Tritons.

(E. Panofsky, *Meaning in the Visual Arts* (1955),
Harmondsworth: Penguin Books, 1970, pp. 284–6)

The key to the language and the meaning of this passage of writing lies in the words of the first sentence: 'Dürer had gained access'. An iconographic argument is only convincing if the writer can persuade the reader that the artist in question could have known or seen certain 'prototypes'. From these the whole chain of connection stems. There are a number of linguistic clues in this passage to the sort of scholarly method that is being employed. Notice the reference to

'a double detour', suggesting a complicated journey, and to 'linguistic and emotional vernacular', an abbreviated way of describing a complex literary transformation.

The characteristic argument of the iconographical study stems from a wide range of learning; thus the writer's main problem is how to put his material over to a reader unpractised in History of Art. Panofsky endeavours to overcome this problem in two ways. In the first place he divides his material into two sections; it is possible to read only the text, to take for granted that he has sufficient supporting evidence for the suggestion that it was possibly Politian who translated Ovid into the 'linguistic and emotional vernacular of his time'. On the other hand, the scholarly reader may refer to the footnote on this subject. In the second place, Panofsky assists his reader to a certain extent by offering complementary clauses. We may not know that 'Quattrocentro' is the Italian way of describing the fifteenth century, the 'fourteen-hundreds', we would say. We might have difficulty with '*mise-en-scène*' and might quite reasonably ask why the author, since he is writing in English, could not simply say 'stage setting'. On the other hand, assuming that some of his readers will not know what constitutes a fifteenth-century stage setting, Panofsky proceeds to give us a list of some of the ingredients: satyrs, nereids, and so on. The German phrase in the last sentence is translated as 'busy little things' which makes one wonder whether, although the phrase serves to remind us that we are dealing with a northern, German artist, it was really necessary in the first place.

In the following passage, another, more recent writer on medieval art takes a rather different approach. This passage attempts to explain how people in the Middle Ages might have viewed gold; it does not assume that gold meant the same then as it does today but it uses a very contemporary (and even colloquial) language to convey this:

> Because gold remains a status symbol today, we can get a sense of how medieval observers might have feasted their eyes on its shimmer, aware, in even the most exalted statue or panel, that it was 'worth its weight in gold'. Gold was, like so many symbols, a signifier of either of two opposed extremes – good and bad. That the 'idols of the nation are of silver and gold' made them even more heinous because the pagan gods had been the focus of excess luxury and misspent wealth. There is also the important historical context explored by Marc Bloch, who shows that there was a dearth of gold in Western Europe in the twelfth and thirteenth centuries compared to the rich resources of Byzantium and Islam.

This shortage of actual gold coinage must have affected how people saw it used in art objects both to glorify, in its rarity, the King of Kings and to denigrate the avaricious pagan's filthy lucre.

> (M. Camille, *The Gothic Idol: Ideology and Image-Making in Medieval Art*, Cambridge: Cambridge University Press, 1989, p. 260; author's footnotes omitted)

Camille is determined to be 'user-friendly' and he opens this passage with an appeal to his readers through their own experience. Advertisements for gold watches and necklaces are a familiar part of Western culture. He then works around the everyday saying 'worth its weight in gold' to make the point that in the context of which he is writing this was probably literally true. But it is the symbolic worth of gold that concerns him, so he moves on with short quotations to make the point that then, as now, the supply of this commodity affected the way people saw it. Concluding the paragraph with a reference to 'filthy lucre' reminds us, again, that our everyday sayings have their origins in the far-distant past. His use of language thus serves to link his audience in the present with the events of the past which he is examining.

All writers have a perspective on or an approach to what they are dealing with. This is true even if they disclaim any approach or if they offer an account so apparently magisterial and authoritative that it appears to be universal truth rather than one of many possible arguments. In writing about the art market, for example, the language employed is often that of sociology and economics, suggesting absolutely quantifiable certainties, verifiable data and so on. Here, for example, is a short paragraph from a study of how and why certain artworks are bought or stolen:

> In total, the price increases caused by the rise in the American demand for art leading to more theft is responsible for some, but possibly rather minor negative external effects (and these are partly compensated for by the positive external effect of better preservation). Exactly the same effects would occur if art prices rose owing to increased European demand. It must then be concluded that there is little reason to argue against the international market in art on the basis of the externalities produced.

> (B. S. Frey and W. W. Pommerehne, *Muses and Markets, Explorations in the Economics of the Arts*, Oxford: Blackwell, 1989, p. 122)

We should notice how the use of phrases like 'In total', with which the passage opens, convey the idea of an absolute overview, a summation of facts. This is the language of Economics; we are told of 'demand', 'external effects', 'price', 'effect'. This is the language of materialism, of things that can be traced in terms of cause and effect.

Art historians have been traditionally concerned with precedents. One of the first concepts that many students seize upon in their early reading about History of Art is the idea of influence: who borrowed or inherited what from whom. The concept of influence has of recent years been subject to a pretty thorough scrutiny, as have the reasons for the powerful hold it has had on generations of art historians. None the less, the question of the antecedents, association and special qualities of works of art still concern art historians. In the following passage from a book which was published in 1973 but which has been frequently reprinted and remains widely recommended by undergraduate teachers, the author employs no apparently specialist vocabulary, no meta-language of art history; his writing is, none the less, deliberate and controlled and makes an effect through conscious linguistic manipulation:

> In the decades after 1848, the examples of Courbet and Baudelaire, and the different responses to politics they embody, stayed obstinately alive. It is curious how many of the best artists, later in the century, tried to combine those responses, however at odds with each other they seemed. Manet in the 1860s, for example, paying homage to Baudelaire's disdain for the public life, but aping Courbet's, and hoping against hope – or so the viewer feels face to face with *Olympia*, or looking on at the *Execution of Maximilian* – for a public picture, a picture to state exactly what its audience did not want to know. Or think of Seurat in the 1880s, keeping silent about politics, in spite of the anarchism of his friends, staking his claim to artistic precedence with all the pedantry of a later avant-garde; but producing the *Grande-Jatte* or the *Chahut*, images of joyless entertainment, cardboard pleasures, organized and frozen: pictures of fashion, and thus of the place where public and private life intersect.
>
> (T. J. Clark, *The Absolute Bourgeois, Artists and Politics in France 1848–1851*, London: Thames & Hudson, 1973, p. 181)

The language of Art History is here the language of the present, the language of continuity. At least, that is the effect the author seems to be endeavouring to achieve. The construction of the first

sentence is striking, dealing as it does first with the period, then with the two individuals Courbet and Baudelaire, both established as representative of a 'response to politics', and, finally, with the continuity of this response, which is expressed with an active verb in the phrase 'stayed obstinately alive' which one associates more usually with a person than with a response. It is the use of active verbs and, frequently, the present tense that gives this passage its persuasive power, its sense of a continuous process: 'embody', 'paying homage', 'hoping against hope', 'looking on' (a phrase which suggests succinctly both the way in which we as viewers look at Manet's *Execution of Maximilian* and the relevance, the contemporaneity, of the event portrayed in the picture), 'staking his claim' and 'producing'. Various words are used by Clark provocatively. 'Best' artists, for example, is likely to arouse vigilance in the reader, though few would disagree that Manet and Seurat, and the examples of their work that follow, are good artists and successful paintings.

Clark exploits the capacity of language to surprise by leading the reader to expect one thing but then giving the opposite or, at least, the unexpected. The reader wants to know in the third sentence what Clark means by 'public', but the definition of a 'public picture' which is provided, 'a picture to state exactly what its audience *did not want to know*' (my italics), is the inverse of what might have been expected. In many ways the language of this art-historical writing is challenging; it is also not without ambiguity. Indeed, Clark exploits ambiguity. In the last sentence of the passage, it is not clear whether 'cardboard pleasures, organized and frozen' is a description of the content of Seurat's paintings or the style and technique in which they are executed. The author does not distinguish between subject and style because both are understood. Perhaps most important is the evident determination of this author to avoid art-historical jargon. The linguistic problems raised by the use of words like 'politics', 'public' and 'private' remain, but at the very least this writing is accessible to someone outside the discipline of History of Art.

A different kind of authoritative language is used by writers who, conscious of the point I have made that all writing on Art History has an approach or a perspective, make the stating of their position paramount in their writing. In other words, they do not assume that we will simply be able to infer where they are positioning themselves *vis-à-vis* the text, the artist, the work (and this is how they would put it, rather than *their* artist, *their* text . . .) but insert

prominently into the writing their own relationship to the objects they analyse and to the writing they are undertaking. This results in language that has been found by some art lovers, accustomed to basking in the vicarious descriptive pleasures of evocative, ekphrastic writing, to be polemical, stern and unyielding.

What we have to remember is that anyone engaging seriously in writing Art History is engaging in a struggle to relate what the French philosopher Jacques Derrida has described as decisions about the frame, about what is external to internal description, or (to put it another way) about how far we are able to interpret anything. When individuals are struggling to find new ways of doing things, languages are being borrowed, adapted, forged, and words are nailed to a masthead to signal the identity of a ship sailing what the mariners (or writers) regard as uncharted waters. So words, in this sense, signal to us the academic affiliations of the writers as well as conveying to us information or ideas, arousing our interest or our opprobrium. To say language indicates to which party or club the writer belongs would sound cynical or pejorative – and this is not what I intend. The 'political correctness' of some forms of writing may be obtrusive. My wish is, however, not to endorse this but to convey the way in which art-historical language serves many purposes, and one of them is to indicate 'This is where I (or we), the writer(s) stand in relation to the material we are writing about and these are the academic fields of enquiry where we think we have allies'. This may involve an implicit riposte to another party, a challenge, or a reply to an unnamed opposition.

In the following paragraph from an essay about contemporary women artists, two writers establish their concern with the subject of woman (as artist and as image) and the relationship between the subject of a woman and the issue of race. These two things come together as an examination of the concept of primitivism.

> The *academic orthodoxies* of art history and anthropology have significantly contributed to the *production of primitivism* as a *discriminatory discourse* which *posits an 'other'* as both the *exotic object* for the artist's gaze and an object for analytic scrutiny. Instituted in a culture which is *patriarchal* and *racist*, certain *convergences can be mapped* between the *constitution of a colonial or racial 'other'* and the *production of a subject* woman. And while particular kinds of *oppression* which emerge from this *construction* differ and cannot be *collapsed into a general category* of victimization, it is also evident that the *processes of identification*

and stereotyping in both cases share particular *patterns and characteristics.*

(D. Philippi and A. Howells, 'Dark continents explored by women', *The Myth of Primitivism: Perspectives on Art,* ed. S. Hiller, London: Routledge, 1991, p. 239)

This passage is full of 'buzz-words' which link it into a literature of politics, cultural studies, anthropology and sociology. The fact that there are two authors rather than one is not necessarily significant (there have been notable teams of art historians in the past, especially for large-scale projects), but in this context it may be taken as an indicator of something of a challenge to the single master-voice and an acknowledgement of the importance of collective enterprises in women's scholarship as in women's work generally. Words like 'production', 'instituted', 'mapped' and 'constitution' are all active words, suggesting that knowledge is created and is variable – it is a series of socially constructed invitations or commands to believe, rather than a set of inalienable facts. The word 'discourse' is not used here in its everyday meaning of 'speech' but in the sense that derives from the work of the French historian/philosopher Michel Foucault, to mean competing statements which offer effects of truth, there being no absolute truth.

The difficulties of analysing imagery – one of the traditional preoccupations of Art History – in an age that recognizes the power of language and the impossibility of a single point of view, has led art historians to address very precisely the issue of words and the consequence of their usage in ways much more elaborate and sophisticated than I am attempting here. The author of the following passage (published in 1981 but, again, still central to many undergraduate reading lists) attempts to explain the salient characteristics of an artist, and of writing about that artist, by analysing how certain motifs function as signs within a system of meaning that is not contained within the pictures themselves. The language here derives from linguistics:

In Watteau, a whole narrative structure insists on meaning but at the same time withholds or voids meaning. Let us take the example of this characteristic theatrical costuming. In the theatre, such clothing is part of a general system of conventionalised costumes with exact dramatic and signalling functions. The diamond-patterned costume signals Arlequin, the baggy, white, ruffed costume signals Pedrolino or Gilles, the black cap and gown signal the Doctor. But outside the frame of the stage, in a *fête*

champêtre, such signalling costumes lose their semantic charge, and having lost that original meaningfulness take on all the sadness of depleted signs. Again, the configuration which appears both in the musical analogy and in the biographical emphasis of the Watteau literature: a sign that insists on a signified which is absent, disconnected from the present signifier, at the same time that sign makes the claim for a powerful and attractive signified (melancholy) that is nowhere stated in the painterly signifier.

(N. Bryson, *Word and Image: French Painting of the Ancien Régime*, Cambridge: Cambridge University Press, 1981, pp. 71–2)

In this passage the reader confronts the language of semiology; the meta-language of Art History has been replaced by that of structuralism ('a whole narrative structure') and it is applied not to a particular work or group of works but to an artist. The object of study is no longer a particular painting; not is it, in the conventional sense, the life and work of Watteau. Bryson is concerned with exposing the relationship between what we know of Watteau from the way he has been written about ('the biographical emphasis of the Watteau literature') and what we see on the picture surface. Somewhere between the two a meaning is produced. The question is 'how?'. The sadness of Watteau's paintings has always been acknowledged, but Bryson tries to explain this without recourse to the subjective response of the individual viewer (e.g. this picture has a sad feel to it' it makes me feel sadness). To do this he treats the ingredients of the picture's stories as signs for something outside the picture. The theatrical clothes *signal* certain meanings on the stage which, Bryson indicates, is as much an artificial structure as a picture ('the frame of the stage') but those meanings are lost when the context is a country picnic (*fête champêtre*). It is characteristic of semiological analysis to discard the notion of a painter making a meaning, embodying it within an image. In this passage the subject of the active verbs is not the artist but the narrative structure which means not only the painting as object but the frame of reference in the world in general ('a whole narrative structure insists . . .'). The reference to 'the sadness of depleted signs' suggests the kind of absurdity and bathos that semiologists dealing with visual material can fall into. Neverthe-less, in employing a system of analysis which makes a distinction between an image on a canvas ('the signifier') and the meanings it carries ('the signified') Bryson is able to theorize a problem in Watteau, that is, to point to an underlying principle at work which, it is argued, accounts for the recognized mood of the paintings.

More recently, attempts have been made to detach writing about art from writing both about images and about history as a given set of circumstances. These investigations focus on how we write and how that produces meanings that shift and change constantly. Here, instead of trying to combat the random nature of one person's view in relation to that of another and the difficulties of securing an explanation of an artwork that takes into account our present as well as the artist's past, a writer takes that very randomness as a starting-point. Refusing the idea of academic enquiry as sequential and scientific, she predicates her analysis upon the accidental within a given order, using the image of a game of cards to convey her approach:

> My topic is not Leonardo as an artist but Leonardo as an allegory, as the fulcrum for thinking about historical consciousness in the late twentieth century. I will use a few of his images to problematize the connections between the narrative histories we fabricate about art and artists and the works these accounts talk about. This process involves putting texts together so that a story can unfold around and through them. I readily admit that it's a kind of game, like being dealt a hand of cards, and in that sense has little to do with the canonically accepted notion of expertise. My ace-in-hand here is Leonardo, or at least a couple of his notebook pages and a couple of his paintings, but next to him I want to place Freud, Schapiro, Lacan, Derrida, some Egyptian hieroglyphs, some Albertian diagrams, and Gadamer. The analogy of a hand of cards is appropriate because of its lack of depth and suggestion of randomness. Picture the seven or so cards I hold as fanned out, and it will be difficult to think of them in terms other than as a spatial spread along a surface, undisturbed by what lies under or what came before. Although their face values may differ, it is their momentary relationship to each other that matters: the way each is empowered by the other through the creation of patterns that enable the game to go on.
>
> (M. A. Holly, 'Writing Leonardo Backwards', *New Literary History* 23, no. 1, Winter 1992, p. 174)

For this writer, texts are not passages of writing but objects of study which may or may not be written. Words like 'canonical' and 'expertise' (authoritative, and possibly authoritarian, words) are introduced in order to be dismissed. The author then, however, introduces an alternative canon, as it were, a random list of producers of texts. Phrases like 'face values' and 'spatial spread' work

punningly to reinforce the metaphor of the hand of cards but also to remind us of the traditional concerns of Art History (the interest in surfaces and spatial dimensions) which this writer is committed to moving beyond.

This chapter has been concerned with tracking the kinds of writing students are likely to encounter when studying History of Art at university level. I have looked in detail at *how* art is written about across a range of texts from the deeply traditional to the highly innovative. But what of reading? The first problem for students in these days of diminishing library budgets and increased student numbers is locating a copy. There is no doubt that, wherever you are studying, it will be to your advantage to work in cooperation with your fellow students when locating copies of essential reading. All serious higher education institutions now run reserve and short-loan systems which restrict the period any student can keep a book in their possession. Learning how to use your institutional library is the absolute prerequisite to a successful degree course and this means not only attending all library tours offered to you but taking time in a relaxed way to find your way around. If you are uncertain where to find something, do not hesitate to ask. If you are studying in a city you should take time to locate alternative sources of books and journals, whether in the public libraries or in neighbouring institutions where you may not have borrowing rights but you will probably be able to read. Photocopying is often a solution, though it is important to remember that if you photocopy more than one chapter of a book, even for your exclusive use, you will be in breach of copyright laws. All this adds up to the message: plan your reading, prepare in advance, keep ahead of your course reading list, and do not panic! If you fail to locate the reading you need, seek advice. There may be alternatives.

A bibliography is, or should be, rather different from a reading list. The former will probably give a wide range of publications across the area you are studying; the latter will indicate more precisely those texts which are essential reading for your classes. The two may be conflated into one list on which essential items are in some way highlighted. If you are uncertain about what you should be reading or about what any particular citation means, ask your teachers. There is nothing demeaning about asking apparently basic questions. Scholarly literature is, as I have indicated, extremely complicated and abbreviations may be found on lists (especially for journals with long titles) which may be indecipherable to a newcomer.

Having secured a copy of your text, you will start to read. Find somewhere quiet where you won't be interrupted, or tempted to

abandon a difficult passage to go off with friends for a drink. Most students coming up to university are initially shocked at the amount they are expected to read in a ten-week term or a twelve-week semester. From a restricted series of set books and some background reading, students find themselves facing challenging lists and bibliographies. Effective reading skills are now essential: though there may be books you are required to read cover-to-cover, it is much more likely that it is a section, a chapter, or several different parts that will be relevant to your particular needs. Do not try to read everything in a bibliography. Select and, within that selection, make choices. It is better to read and absorb a limited amount that to rush through and forget hundreds of pages. Use the index to locate key words. Do not try to make notes on everything you read, but write down important headings. Do not copy out whole passages of books; this is a waste of time and sometimes leads inadvertently to plagiarism when someone incorporates into an essay what they thought were notes but which was in fact a transcript. Never write on any book you are reading. One well-tried way of reading intelligently is to have a pile of white paper markers by your side and to pop one into a page when something strikes you as of lasting importance. Write a note on the marker as to why it is important and when you get to the end, review all your markers and, if you still think it is significant, organise your notes into more lasting form on a sheet of paper and file it.

Effective reading is the key to being able to profit fully from your course; if you experience difficulties, seek help. All institutions should have free study skills courses for students who find it difficult to adapt to the pace and demands of university.

5 The literature of Art History

As foreign travel and the mass media have aroused increasing interest in the visual arts in our own century, museums, galleries and commercial dealers in artworks have multiplied and, correspondingly, so has the literature of art. A bewildering array of books on art has become available, although, ironically, it remains difficult enough to find bookshops prepared to stock any range in the more serious art books. This chapter is intended as a guide to the types of art-historical literature that the sixth-form student or the first-year undergraduate is likely to encounter. The literature of History of Art naturally reflects the diversity of approach to the subject discussed in Chapter 2. Here, however, we are not concerned in any way to discuss the content of books that are mentioned or to assess the merit of any particular work. In so far as titles and authors are mentioned, they have been chosen only because they provide suitable examples of certain classes of literature. Additionally, the reader will find in this chapter a short introduction to the retrieval of art historical information stored electronically.

Locating a copy of the book one wants to buy, borrow or consult is a perennial problem for the art historian. With increased numbers of students and increased prices of books, finding an available copy of a necessary text is, as I have remarked earlier, a problem for most students today. Because books on art are more expensive than those on most other subjects the problem is particularly acute for the student of History of Art. Even supposing that the reader can afford to buy a copy of the required book, unless one of the specialist bookshops like Blackwell's in Oxford, Dillon's Art Bookshop in Long Acre, London WC2, or Atrium at 5 Cork Street, London W1 is near at hand, it may be necessary to place an order. For theoretical texts and studies in film, photography, and mass media, Compendium, 234 Camden High Street, London NW1 has a wide selection of books.

Out of London, bookshops stocking a wide selection of Art History are few and far between (though large branches of Waterstones such as that in Deansgate, Manchester, or at 128 Princes Street, Edinburgh may stock a surprisingly comprehensive range of books). Sometimes a gallery shop may be a better bet. The Gallery of Modern Art in Edinburgh, for example, has an excellent bookshop and the National Gallery's bookshop is one of the best in London. Certain paperback series of art books, for example, the Thames & Hudson 'World of Art' books and the Pelican series 'Style and Civilization' as well as best-sellers like Gombrich's *The Story of Art* and John Berger's *Ways of Seeing* are normally to be found in any good bookshop.

The economics of the book trade is not our concern in this work, but, in passing, a word of warning seems appropriate. Art books with good colour plates cost a great deal of money to make and their production is still regarded by publishers as special catering for a small audience. Once art books are out of print it is often quite difficult to persuade a publisher that a reprint would be worthwhile, and even texts which are widely used in educational establishments have been known to be out of print for years. This can be a real problem, though it is encouraging that several firms now specialize in reprints. Dover Press, 18 Earlham Street, London WC2 is one such firm.

What about libraries, then? No library has an unlimited budget and, as the price of books has risen, libraries in any one area have tended sensibly to pool their resources and to consult each other about expensive purchases, thus ensuring that two copies of a book sold at £150 (not so unusual in 1997) are not acquired in the same geographical region. It may be necessary, therefore, for a student living in an area where there are perhaps several libraries to telephone around in order to locate a particular work.

Most university libraries are 'teaching' libraries. That is to say, their holdings reflect the needs of the courses that are taught there. There are, of course, exceptions like the library of the Courtauld Institute of Art, the University of London, which is more in the nature of a reference library. Increasingly as undergraduate dissertations and theses (individual projects on which students work under supervision) become the norm rather than the exception, university libraries find it difficult to cater for all the needs of students. Many of the special reference libraries like the British Library, the National Art Library or the National Library of Scotland do not normally offer facilities to undergraduates, but many big cities now possess

good specialist art-reference libraries. Edinburgh, Manchester, Leeds and Birmingham, for example, all have well-stocked art sections in their central libraries. If you want to keep track of new publications in History of Art, put your name on the mailing list to receive the seasonal catalogues issued several times a year by the big publishers (for example, Yate University Press and Thames and Hudson) or consult the magazine *The Art Book* published by Blackwell.

REFERENCE WORKS

Since the third edition of this book, information technology has revolutionized the experience of finding books in many libraries and, especially, of searching reference works for information. Most students entering higher education will be given instruction on arrival on using the computerized catalogue in their institution's library. This will normally allow a person to find out (by author, title or keyword search) not only whether or not the book they want to read is owned by the library (or on order, or being accessioned) but also how many copies the library possesses, where it is normally shelved, whether it is in the library or out, and if it is out when it is due back. Microfiche catalogues (where a large number of catalogue entries are reduced photographically and read with a magnifying reader, sheet by sheet) are a midway stage in some libraries between old-fashioned card catalogues and fully computerized systems.

The same revolution has taken place in the storage of bibliographic information and other kinds of data. The terms 'hard copy' (for volumes made of paper) and 'on-line' are used to distinguish whether you go and pull down a book from a shelf or go to a computer terminal and ask questions of a database by keying in certain symbols and words according to instructions. Reference works for art historians can roughly be divided into three groups:

1 Those that give biographical information about artists listed by name.
2 Encyclopaedias which contain entries on selected artists and also on techniques, monuments, frequently used terms and important places.
3 Bibliographies.

Since 1996 the availability of up-to-date reference material for the discipline of Art History as widely defined has been revolutionized by the publication of *The Dictionary of Art*, by Macmillan Publishers with an impressive list of advisers and consultants. It has been long

in the making and, like every reference book, it is as good as the individual scholars responsible for the entries. But its coverage is impressive (28,000 biographical articles) and extensive coverage of art and architecture organized to take account of cities, theory, religion, cults and orders, forms and themes, materials, technique and conservation. The aim is that this massive undertaking (34 volumes at the list price of £5,300) will stand as Art's equivalent to the celebrated *Grove's Dictionary of Music*, also published by Macmillan. It is to be hoped that all serious academic and reference libraries will have *The Dictionary of Art* on their shelves by the time this fourth edition of *History of Art: A Students' Handbook* is published. It is also, however, likely that the two older standard reference works for the discipline will continue to be useful though neither is in English. They are: U. Thieme and Felix Becker, *Kunstler Lexikon*, published in Leipzig between 1900 and 1970 (with a new edition coming out at the rate of two volumes a year, priced £150 per volume, since 1991), and Emmanuel Bénézit, *Dictionnaire critique documentaire des peintres, sculpteurs, dessinateurs et graveurs . . .*, of which the most recent edition was published in Paris in 1976. The English language *Penguin Dictionary of Art and Artists* and the *Oxford Companion to Art*, are extremely basic, but the *Dictionary of National Biography* can be of use to students seeking information on a British artist born before 1900. This is in the process of being revised and updated at time of going to press.

The *Encyclopaedia of World Art* (New York 1959–68) remains a useful reference tool despite its now rather distant publication date; it contains substantial single- or group-authored essays on major period and genre topics like 'Etruscan' or 'Portrait'. It can still be a good place to begin, though it needs to be supplemented with more recent and more specialist publications. Like all big reference books, encyclopaedias are published over a long period; they reflect the priorities of the age and country in which they were produced and their quality varies according to the individual authors recruited. The *Encyclopaedia Britannica* also contains many useful entries for art historians. A student engaging with Venetian art might do worse than start with the history of the Venetian republic that is published here.

Remember that the *Encyclopaedia Britannica* has been through many editions; if you use early editions you may be working with an authentic historical source rather than with an up-to-date reference book. For example, the entry on 'Architecture' in the eleventh edition published 1910–11 runs from page 369 to page 444 and offers a stylistic survey from Ancient Egypt to the modern, illustrated with

engravings and photographs. The author asks rhetorically what the future of modern architecture will be, and prophesies the survival of classical styles along with a greater *rapprochement* with engineering and the decorative arts. We might conclude that he was hedging his bets, but what such a text has to offer is not a 'state-of-the-art' analysis but a genuine contribution to historiography of the sort discussed in Chapter 2.

There exist also reference books which provide information on sale prices and exhibitions. There are directories of museums and art galleries as well as of country houses in Great Britain open to the public. These can usually be purchased for a small sum from a good museum bookshop or consulted in a public library. The most useful of all the (confusingly disparate) directories is the *International Directory of Arts*, published in Germany in two volumes and in four languages. It is revised and re-issued every few years and contains vital information under headings such as 'Museums and Galleries', 'Universities and Academies', 'Societies and Associations', 'Artists, Collectors, Dealers and Auctioneers', 'Art Publishers', 'Periodicals and Journals', 'Antiquarian Bookshops', 'Restorers', and 'Experts'. Most public libraries hold these volumes in their reference sections, and there are few guidebooks that can equal the detailed information on museums throughout the world and their opening times. So consulting this before setting off on holiday is a good idea.

Dictionaries of signs and symbols, glossaries of art terms and other such specialist reference books are also available in confusing numbers. James Hall's *Dictionary of Subjects and Symbols in Art* (revised edn London: John Murray, 1987) is a popular paperback and readily obtainable. It is much used by undergraduates, who may, however, need to go to something more specialized as they advance in their studies. Otherwise what you need will depend very much on what area you are studying. *Who's Who in the Ancient World* by Betty Radice, first published in 1971 and reprinted many times by Penguin in paperback is, for example, a handy accompaniment to the study not only of antique art but also of periods of classical revival such as the eighteenth century.

The third group of publications is essential for the research student but can be very profitably used by someone studying History of Art at a less advanced level. For example, if a student wished to know where to read about an artist whose work is so recent that their name has not yet found its way into any of the dictionaries or encyclopaedias, he or she should search in the *Art Index* or *Art Bibliographies Modern* for references to articles in journals

or reviews of exhibitions and thus build up a bibliography or list of publications about the artist. The *Art Index*, published quarterly in New York (H. W. Wilson), covers archaeology, Art History, arts and crafts, photography, film, planning and all subjects related to the visual arts. Illustrations, even when there is no accompanying text, are also indexed. *Art Bibliographies Modern* (published by ABC-Clio Inc.) concentrates on the twentieth century.

Alongside this standard reference work are many new projects such as the New York Museum of Modern Art files on artists (including newspaper clippings, exhibition announcements and correspondence) which are now available on microfiche from Chadwyck-Healey, one of the publishing firms that has specialized in this kind of venture during the past two decades. The cost (approximately £17,000) is likely to make it a rare commodity at least in Britain where library budgets in the public and private sectors are severely constrained. The long-established bibliographic service RILA (*Repertoire internationale de la littérature de l'art*), originally published only in hard copy (1975–89), abstracted and indexed current publications in all areas of Art History. It is now run by the Getty Art History Information Program in the USA and is available in hard copy (in English) and on-line (through Dialog and Questel) from many university libraries throughout the world as *BHA* (*Bibliography of the History of Art*). The Getty also administers the *RAA* (*Repertoire d'art et d'archéologie*). Similar services available for architectural historians are the *Architecture Database* (1978–), an on-line catalogue of the British Architecture Library of the Royal Institute of British Architects and the *Architecture Index* (1979–). *The British Humanities Index* is a major compilation of articles on the arts, economics, history, politics and society.

ELECTRONIC RESOURCES

Major reference works such as those discussed above are available not only in hard copy but also 'on line' (that is via the internet) or on CD ROM (that is from a computer disk). In both cases, the information is accessed from a computer terminal. Lists and indexes available in this way are multiplying every year and they range from the comprehensive (*The Art Index* and the *Design and Applied Arts Index*) to the more specialized (the *Eighteenth-century Short Title Catalogue* and the *Dutch & Flemish Masters*). In England, Birkbeck College, University of London has been a pioneer in the uses of computers for Art History. More recently the Getty Information Institute

has taken the lead. The use of computers both for image retrieval and for data collection and exchange is now widespread and has made an impact on all major departments of History of Art. The ease with which researchers and students can browse among images and access basic information as well as exchange news and ideas has been transformed. One example will suffice. The Courtauld Institute of Art in London has long been home to two major History of Art Photography Research Libraries: The Witt Library (paintings, prints and drawings) and the Conway Library (architecture, architectural drawings, illuminated manuscripts, medieval wall and panel painting, stained glass, sculpture, ivories, metalwork). Both libraries are open to the public and at the time of writing free of charge. Both are also desperately in need of financial support. The Witt computer index provides access via their titles to approximately 110,000 photographic reproductions of American and British paintings, drawings and prints housed in the Witt Library. It does not provide the images themselves. Through a system called ICONCLASS, the database can be searched according to a detailed breakdown of subject matter. The quality of imagery on CD ROMs is improving all the time; the paintings of the Norwich School of Artists can, for example, be looked at in this way (price £45.95, HMSO) as can a selection of images from the National Gallery, London.

All databases are only as reliable as the information that is fed into them; electronically retrieved data can only be a starting point. In the case of the rapidly increasing range of sites accessible through the internet, the idea of the virtual reality museum (the possibility of browsing through the slide collection of the Architecture Slide Library at the University of California, Berkeley or looking at works of art at the Whitney Museum) is immensely attractive but students need to be aware that while afternoons spent 'surfing' will be amusing and informative, it is knowing how to integrate your new-found information into your own day-to-day work that counts. Be sure to leave enough time to deal with the good old-fashioned medium of the book and be doubly sure to go and spend time with actual works of art.

The internet offers basically two kinds of communication for art historians: lists (which are like clubs which you join for the exchange of information) and websites (which are more long-term sources of information and imagery). Websites are openly accessible but lists have procedures for membership application. The access code for the Getty, for example, is http://www.gii/getty.edu, while the Fogg Art Museum and Harvard University's collections database can be accessed at http://www.fas.harvard.edu/artmuseums. There is

no doubt that at present the most useful aspect of all this for art historians is the possibility of searching on line in a database like *Art Bibliographies Modern*. It remains relatively unusual for under-graduates to have institutional access to the internet. Moreover, it hardly needs to be said that things change with great rapidity in this area and that issues of copyright in relation to image distribution still have to be resolved.

GENERAL HISTORIES AND SURVEYS

These are the books that students of History of Art usually first encounter; they may be period-based, organized around a notional movement in art, or genre-based (i.e. devoted to the arts and architec-ture of any given period and country, on a body of work characterized by style, or on a type of art-production like the portrait or landscape painting). They are useful provided the reader appreciates the intel-lectual constraints under which such publications are produced. Any survey or general history depends upon notions of continuity and development, so it is difficult in such works to challenge received ideas about historical process. Moreover, because they often cover large time-spans, they are extremely selective in what gets included and tend, therefore, to depend upon a rather broad (and conservative) consensus about what is important and significant. There is an air of the definitive and inclusive about a book like S. F. Eisenman's *Nineteenth Century Art: A Critical History* (London: Thames and Hudson, 1994) which, for all its usefulness, may seduce the inexperi-enced reader, may persuade him or her that whatever is found there represents the whole that can be said. The more popular among such works can be simplistic and misleading and, often many times reprinted by publishers with an eye to quick profits, may not reflect recent scholarship. So look in the front cover when you take a general history off the shelf and see when it was first published and whether it has ever been revised. Lavish illustrations do not compensate for a superficial or cliché-filled text. Some volumes of *The Cambridge Cultural History of Britain* (edited by Boris Ford), a series not devoted exclusively to the visual arts, have excellent essays of immediate rele-vance to art historians.

Probably the most famous series of period surveys are the Pelican Histories of Art, first published in the 1950s. The rights have been pur-chased by Yale University Press, who are issuing revised editions in larger format with improved imagery. The omission of some areas of Western art is being rectified and new books have been commissioned

on Pacific and Oceanic art, arts of the Americas, Australian art and the arts of Africa. 'A' level students may encounter the Cambridge Introduction to Art. These are short accessible texts, well illustrated, and (though limited in range) dependable in content. For a richer and more provocative approach to period study, students will do well, however, to move quickly to a book like Michael Baxandall's *Painting and Experience in Fifteenth-Century Italy: A Primer in the Social History of Pictorial Style*. First published by Oxford University Press in 1972, this is a classic of its kind, approaching the idea of a period with an unusually questioning mind. A further example of an innovative approach to the art-historical study of a period and place (avoiding a restrictive notion of genre as well as the list-of-artists ingredient of general histories) is *The Rococo Interior: Decoration and Social Spaces in Early Eighteenth Century Paris* by Katie Scott (Yale University Press, 1995).

It has been argued (by G. Pollock and R. Parker in *Old Mistresses: Women, Art and Ideology*, London: Routledge, 1981) that surveys have written women artists out of the history of art. If this is so, a great deal of effort has been expended over the past decade in restoring women artists to the canon, and it is now possible to purchase surveys that deal exclusively with the work of women artists (for example, Deborah Cherry's *Painting Women*, Routledge, 1993). A further criticism might be that they tend to concentrate on Western art and overstress post-Renaissance art. Hugh Honour's and John Fleming's *A World History of Art* (4th edn London: Macmillan, 1995) makes, however, an impressive attempt to balance East and West, ancient and modern.

Books on movements or developments that have been conveniently labelled (usually by critics rather than by participating artists) for posterity are available by the dozen. Studies of Impressionism, Fauvism, Cubism, Surrealism vary enormously in value as regards both the text and the quality of the illustrations. Extreme care is necessary in the choice of these books. It is difficult to lay down hard and fast rules but there are two useful criteria. In the first place any serious study of a movement in art should include more than anecdotal discussion of the critical history of the period or group (in other words, what was said by critics and the public about works of art and how the artist came to be given this particular name). These are, after all, labels that have been invented largely for the convenience of 'packaging' history and, consequently, of simplifying it. Therefore, in the second place, a worthwhile and successful study of a movement in art does not seek to establish uniformity at the

expense of contradiction and variety. Anyone who has looked at the activities and creativity of a group of artists at any one period of time recognizes the problem that frequently faces the historian. All the participants seem so various, so eccentric, so individual that one is bound to ask 'Whatever did they have in common?'. The question is simple but the answer is complex. The art-historical study that seeks to iron out differences or to ignore paradoxes in the interests of a neat explanatory account must be suspect. For example, any study of Impressionism that lacks a very serious evaluation of the differences between the objectives and methods of Monet, Renoir and Pissarro should be regarded with the deepest suspicion.

Sometimes books on movements are at one and the same time also studies of style, but it is important to distinguish here the publication which deals less with a movement that can be located historically in time than with common characteristics in the appearance of works of art. For example, most serious studies of the late nineteenth-century European style known as art nouveau include (whether they convince us or not) a consideration of the possible origins or antecedents of this style in the curvaceous forms of eighteenth-century rococo or the convolutes and scrolls of medieval illuminated manuscripts.

ANTHOLOGIES OF PRIMARY SOURCES

The expansion of Art History across a range of educational institutions has led to increasing provision of what might be called 'teaching collections'. These are anthologies of historical published material of importance to art-historical study, whether from the distant past or from more recent times, whether written by artists or by critics. These publications give the reader access to excerpts from texts which have turned out to be of particular importance for shaping our ideas about art and its production. *A Documentary History of Art*, edited by Elizabeth Holt (begun in the 1940s but revised and reissued by Anchor Books) was one of the first, and it was followed by *Sources and Documents in the History of Art*, published by Prentice-Hall International Inc. in volumes covering different periods and nations and edited by different individuals. More recently the field of British art has been well served by Bernard Denvir's *A Documentary History of Taste in Britain*, published by Longman, while *Art in Theory 1900–1990*, edited by Charles Harrison and Paul Wood (Oxford: Blackwell, 1st edn, 1992) includes texts by artists, critics, philosophers and political and literary figures.

MONOGRAPHS

People often mean different things when they speak of a 'monograph', but for our purposes it means a study of the work of a single artist or group of artists. An example might be Susan L. Siegfried, *The Art of Louis-Léopold Boilly: Modern Life in Napoleonic France* (Yale University Press, 1995), which, as the title suggests, is not a study which is confined to listing and describing works by an artist but includes a substantial element of historical and textual interpretation.

CATALOGUES

There are two main types of scientifically presented catalogue of works of art with full historical and physical documentation provided. On the one hand there is the critical catalogue of one artist's work or of that particular part of an artist's *oeuvre* (the term generally used to denote the entire known output of an individual) which is in one medium. The examples I am using here as a demonstration of how a *catalogue raisonné* (a reasoned catalogue) works are the drawings of Parmigianino, a sixteenth-century Italian artist, and the paintings of Emil Nolde, who died in 1956 (Figure 20). The other type of catalogue is that prepared by a museum or art gallery (or on behalf of a private collector) on a chosen group or category of works in a permanent collection. These are usually selected according to period, school or medium. Examples of such publications might be *Jewish Ritual Art in the Victoria and Albert Museum* by Michael E. Keen, published by HMSO in 1991 or *Stained Glass before 1700 in American Collections*, published in many volumes over a long period by the University Press of New England (Hanover, NH). Typically, catalogues like these take many years to compile and are published volume by volume sometimes over many years.

A catalogue entry should contain, in compressed form, all the important factual data available at the time of publication about any one of a group of works of art. The illustrations on pp. 114–15 show entries from the *catalogues raisonnés* on Parmigianino and Nolde named above. Although there are slight variations in format from catalogue to catalogue, the process of decoding is more or less the same. As new information becomes available, catalogues are revised and supplements are published. Before consulting any catalogue entry, it is as well to look at the front of the book, where you will usually find a list of abbreviations and guidance on accessing and using the information. It is also worth bearing in mind that *catalogues*

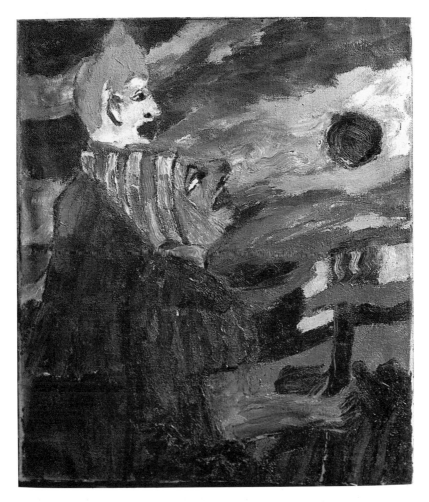

Figure 20 Emil Nolde, *Schwärmer*, 1916, Rheinisches Bildarchiv, Cologne

The 'right' side of the paper

Title given to this drawing

The number in Popham's catalogue

Recto 748

STUDIES OF FEMALE HEADS, OF A WINGED LION
AND OF FINIALS (PL. 34)

Medium

Red chalk and pen and ink.

The plate numbers in Popham, vol. II

Verso

The reverse side of the paper

LADY AND GENTLEMAN SEATED WITH FOLIAGE
BEHIND (PL. 35)

Title given to the drawing on the reverse

Medium

Pen and brown ink.

18·5 × 14·5 cm. (top corners cut).

Dimensions (height by width) and material condition

PROVENANCE: Sir P. Lely (L. 2092); J. Richardson, senior (L. 2184); Thomas Hudson (L. 2432); B. West (L. 419); John Malcolm of Poltalloch.

Where the drawing has been and to whom it has belonged. Among the early owners are four famous artists.

LITERATURE. Gathorne-Hardy Catalogue, no. 34; Popham, pl. XV (recto), pl. XVI (verso); *Master Drawings*, vol. I (1963), p. 3 (repr. pl. 4); Louvre Exhibition 1964, under no. 57; A. G. Quintavalle, *Paragone*, 209 Arte (1967), p. 9, *Affreschi giovanili*, pp. 91 and 107 (repr. fig. 51 verso).

Previous publications (including exhibition catalogues) in which this drawing has been mentioned or discussed

The heads, full-face and in profile, on the recto are probably designs for the terra-cotta heads which terminate the pendentives of the vaulting of the frescoed chamber at Fontanellato (Freedberg, figs. 21 ff.); the pen and ink sketches are for the finials in the four angles of the same chamber. I have suggested that the gentleman on the verso may be identified as the Gian Galeazzo Sanvitale of Fontanellato, whose portrait Parmigianino painted in 1524 (fig. 111).

The more regular writing on the recto seems to be in Parmigianino's hand.

In this section, Popham tries to describe objectively the subjects of the drawings and to identify the figures.

In this section, Popham disagrees with a previous writer (details of whose publication are listed at the front of the catalogue)

In the article and the book cited above Signora Quintavalle claims that the full-face and profile heads on the recto are not studies for the terra-cotta finials but drawings from the life of Paola Gonzaga, wife of Gian Galeazzo Sanvitale, whom she also believes to be the lady represented in the lunette over the window in the frescoes at Fontanellato (Freedberg, fig. 26) as well as on the verso of the present sheet. She quotes no evidence to support this identification. Is it perhaps based on an unpublished portrait in the series of Sanvitale family portraits at Fontanellato? Litta does not record the date of Gian Galeazzo's marriage to Paola, daughter of Lodovico Gonzaga of Sabbioneta, nor that of the births of any of the nine children whom she bore him.

This is a cross-reference to another entry in this catalogue

For a list of the drawings which I believe may have been made at Fontanellato about 1524, the reader is referred to the note on the drawing at Cincinnati (60: pl. 38).

A. E. Popham, *Catalogue of the Drawings of Parmigianino*, New Haven and London, 1971, vol. I, p. 215

Catalogue number ascribed ⟶ 739 ▷
to the painting in this
publication. Title in German ⟶ SCHWÄRMER
and English ⟶ *Dreamers*
Date of execution ⟶ 1916
Medium ⟶ Oil on canvas
Dimensions, height ⟶ 101 × 86 cm
by width

Inscriptions
and signatures

Signed l.r.: 'Emil Noide'
Inscribed on the stretcher: 'Emil Nolde
Schwärmer'

An early catalogue
citation

HANDLISTS
1930 '1916 Schwärmer'

previous
owners

HISTORY
Willy Hahn, Köln (before 1924)
Josef Haubrich, Köln (1924)
Wallraf-Richartz-Museum, Köln (gift from
Haubrich, 1946)

LOCATION

Present owner

Köln, Museum Ludwig (1986)

EXHIBITIONS

Noide exhibitions in which
this work has been shown

A 1920 Dresden. Emil Richter
1922. Hannover. Kestner-Gesellschaft
1958 Zürich, Kunsthaus, no.35
196⁷ Stockholm. Moderna Museet, no.32
19⁷3 Köln, Kunsthalle, no.⁷2 (col. ill.)
B 1925 Köln, Kunstverein: *Aus Kölner
Privatbesitz*, no.66
1946 Köln, Wallraf-Richartz-Museum
Sammlung Haubrich, no.9⁷: Circulating
Exhibition: 194⁷-1955 in Europe and São
Paulo

Group exhibitions in
which this work has
been shown

1948 Bern, Kunsthalle: *Paula Modershon
und die Maler der 'Brucke'*, no.118
1950 Recklinghausen. Kunsthalle: *Deutsche
und französische Kunst*, no.14⁷
1964 Firenze. Palazzo Strozzi: *Mostra
dell'Espressionismo*, no.444 (ill.)
19⁷1 Tokyo. National Museum of Western
Art: *Der deutsche Expressionismus*, no.45
(col. ill.)
1984 Bruxelles. Palais des Beaux-Arts:
Expressionnisme à Berlin, no.132 (col. ill.)

REFERENCES

Publications in which
this painting is mentioned

Luise Straus-Ernst. 'Die Sammlung Haubrich in
Köln'. *Das Kunstblatt*, vol.XI, no.1. Potsdam
192⁷, pp.25-34 (ill. p.26)
Moderne Abteilung - Sammlung Haubrich.
catalogue. Wallraf-Richartz-Museum. Köln
1949. no.19⁷ (col. ill.)
L.G. Buchheim. *Die Künstlergemeinschaft
Brücke*. Feldafing 1956 (col. ill.)
Werner Hoffmann. *Zeichnung und Gestalt*.
Frankfurt a.M. 195⁷ (ill.⁷)
Joseph-Emile Muller. *L'Expressionnisme.
Dictionnaire de Poche*. Paris 19⁷2, p.104
(col. ill.)

M. Urban, *Emil Nolde, Catalogue Raisonné of the Oil Paintings*, vol. II,
1915–51, trans. G. Parsons, London: Sotheby's Publications, 1990

raisonnés serve the needs not only of museums and galleries but also of auction houses and dealers, who may have sponsored their publication.

EXHIBITION CATALOGUES

During the last twenty years, exhibition catalogues have become more detailed, more thoroughly researched, better illustrated and increasingly indispensable to the art historian. They have also become very expensive, and as a result many exhibitions offer handlists of exhibits for a small price, enabling visitors to get around the exhibition and to consult the catalogue in the library later. In principle the exhibition catalogue entry performs some of the functions of the *catalogue raisonné* entry but usually with less detail. It offers, for example, not information on all the known drawings by Parmigianino, but documentation on works of art that have been assembled for display from collections both public and private all over the world. The subject of the exhibition may be an artist, a period, a theme or any one of a great variety of other things. There will probably be an introductory essay or essays as well as the entries. It is sometimes the case that an exhibition catalogue is the only item in print on a particular artist, and for contemporary art in particular exhibition catalogues are a uniquely valuable resource. Ideally one should visit the exhibition with the catalogue but it may be so heavy that you don't want to carry it round with you and, in any case, even long after the show is over, the catalogue remains a rich source of interest and enjoyment.

STUDIES IN ICONOGRAPHY

Iconography was described by Erwin Panofsky, widely regarded as one of the founding fathers of the discipline of Art History, as 'that branch of the history of art which concerns itself with the subject matter or meaning of works of art, as opposed to their form' ('Iconography and iconology: an introduction to the study of Renaissance art', in *Meaning in the Visual Arts*, 1955; new edn, 1995). Panofsky identified two stages of study: first the motifs in the visual field have to be identified and classified (iconography); and, second, their deployment has to be analysed historically. This he terms iconology. Books on iconography usually take a specific theme and trace variations in the presentation and meaning of that theme in the work of different exponents within a given period of time. Alternatively they may take particular monuments or images and

interrogate the subject-matter. Many art-historical books employ iconography and iconology as methods among others, but iconographical studies as such usually make apparent in their titles that they are concerned with the subject-matter of artworks. *Forms of the Goddess Lajja Gauri in Indian Art* (by Carol Radcliffe Bolon, Penn State Press, 1992) and *Turner's Classical Landscapes; Myth and Meaning* (by Kathleen Nicholson, Princeton, 1991) announce their approach in their titles.

Although iconographical and iconological analysis remains pervasive throughout the discipline, including among modernists, it is still particularly strong in publications on art in early Christian, medieval and early modern Europe because of the programmatic nature of much art produced in societies where religious belief and practice were powerful. A typical example of such a book would be *The Iconography of the Sarcophagus of Junius Bassus. Neofitus lit Ad Deum* by Elizabeth Struthers Malbon (Princeton, NJ: Princeton University Press, 1991). Traditionally, since iconographic study involves charting the incidence of repeated motifs and changes and transitions in meaning, it is backed up by a huge apparatus of footnotes, ranging through a variety of languages and expanding the substance of the main text in all directions.

THEORY

Any self-respecting art historian will ensure that his or her work is underpinned by theory and will demonstrate how the theory works in relation to the examples from 'real life' that he or she has adumbrated. Let's take a hypothetical and deliberately fantastic example relating to a body of work with which most people in the West are familiar. Let us suppose a theory that Impressionist artists in the second half of the nineteenth century were exposed to derision on an unprecedented scale and in a hitherto unknown range of public media so that a crisis was precipitated that permanently disabled them from engaging with the idea of the public as a collective. The evidence to support this theory might then be marshalled by calling attention to the high proportion of canvases where the middle distance is emphasized as an empty space and where crowds are dealt with in a very summary fashion. Whether the theory is convincing will depend on how far the evidence (based on empirical findings) is convincing. Nor will empirical work, meaning that based on experience (and, by implication, lacking theory) stand up to scrutiny on its own. To take another exaggerated and hypothetical example, an art historian assembles a huge

amount of data on Gauguin in Tahiti based on how many canvases he painted per week and of what dimensions. This evidence tells us nothing without a theory, whether it be based on climate (more in the hot season and fewer in the cold), the market (larger canvases mean more money), psychoanalysis (the intervals in the production of canvases represent a masculine and Western response to the female life rhythms of Tahitian inhabitants) or anthropology (the production of canvases as a counterpart of the social and religious rituals or the indigenous population).

Over the past two decades there has been an explosion of theory in all the humanities disciplines and it is over theory and its place in the academy that, as I indicated earlier, the fiercest and most bitter battles have been fought. To sceptics, the theoreticians are self-indulgent intellectuals playing games. To the proponents of theory, their opponents are obstinate and blinkered reactionaries who are satisfied with simple causal explanations. There is no doubt that engagement with theory has enriched Art History as a discipline and that excesses, if such there are, will in the fullness of time appear as mere hiccoughs in the shaping processes of the discipline. History must cohabit with theory and theory with history. The impact of theory on the discipline will be evident to any student browsing through some of the journals named in the final section. Michael Anne Holly's essay on Leonardo, mentioned in Chapter 4, exemplifies a stance which unapologetically places theory over history as the driving force.

While the issue of the role of theory and the importance of the work of philosophers like Jacques Derrida for students of visual culture remains highly contentious (one of Derrida's books is called, provocatively, *The Truth in Painting* (1987)), theoretical books have long been central to art-historical study. These are the books which examine the doctrines and patterns of belief, the theories and principles that (it can be argued) informed an artist or a group of artists. Classic studies of this kind are Anthony Blunt's *Artistic Theory in Italy 1450–1600* (1940) and Rudolf Wittkower's *Architectural Principles in the Age of Humanism* (1949). Magisterial works of this sort are less in tune with contemporary approaches, which tend to allow the disputatious and fragmented nature of intellectual enquiry to show itself. Accordingly, a collection such as *Visual Culture. Images and Interpretations* (eds, N. Bryson, M. A. Holly and K. Moxey, University Press of New England, 1994) not only has no single point of view and no unifying language but actually highlights debate by including a response by a different author at the end of each chapter.

BOOKS ON TECHNIQUE

The most important books on technique are, as far as the art historian is concerned, often those which have been written by artists themselves. Treatises like Leon Battista Alberti's *Della architectura, della pittura e della statua* (originally published as three separate books but available as a collection in English translation since 1755), Leonardo da Vinci's *Trattato della pittura* and Cennino Cennini's *Il libro dell'arte* (all of which are available in modern English translations) are a mine of information on the techniques and practices of Renaissance painters and, since their authors did not hesitate to digress into anecdote, they are also very entertaining reading.

Many worthwhile and interesting books on technique were published during the second half of the nineteenth century when the creation of national museums in many European capitals lent impetus to scientific and analytical studies of the material of art. Despite its disconcertingly long title, Mrs Mary Philadelphia Merrifield's book *The Art of Fresco Painting as practised by the Old Italian and Spanish Masters with a preliminary inquiry into the nature of the colours used in fresco painting, with observations and notes* (1846) is readable and informative and, as it exists in a reprint of 1952, is not as inaccessible as at first might appear.

These older books should be consulted and read alongside the more recent reference works on the subject of materials as their authors were constrained by the technical expertise and the historical interests of the period in which they lived. Perhaps the best known of these is Max Doerner's *The Materials of the Artist and their Use in Painting with notes on the techniques of the Old Masters* (1976, translated and revised). Books that originated as exhibition catalogues for works in particular media have also become useful general texts. Two examples are Marjorie B. Cohn, *Wash and Gouache: A Study of the Development of the Materials of Watercolour* (Cambridge, Mass.: The Center for Conservation and Technical Studies, Fogg Art Museum and the Foundation of the American Institute for Conservation, 1977) and Susan Lambert, *The Image Multiplied* (London: Victoria and Albert Museum, 1987).

There is a large and highly specialized technical literature on art and conservation, much of it coming from well-endowed museums and foundations in North America. While much of this is necessarily somewhat inaccessible to the untrained, major exhibitions often incorporate this kind of data in manageable form and a publication like the National Gallery's technical bulletin can make fascinating

reading and enhance one's knowledge of the material construction and condition of works of art. There, too, computers have made an impact. Infra-red imaging is a photographic process used to reveal the under-drawing in paintings on pale grounds. Computers have greatly enhanced this process by ensuring precisely the right wavelengths of infra-red and through their capacity to amalgamate a mosaic of individual shots overlaid with faint colour imagery of the visible painted surface. It is, however, important not to be dazzled by science and technology; technical matters are also historical matters when dealing with artefacts and, however wonderful new techniques for dating or for analysing pigments may be, what matters is how we interpret the evidence that such techniques provide.

JOURNALS

Journals that publish articles on art, Art History, material and visual culture, aesthetics and media present nowadays a vast and confusing array. It is testimony to the health of Art History and its related disciplines that not only have all but one of the journals mentioned in the second edition of this book survived since 1986, but they have been augmented by many others. Academic journals demonstrate – or should demonstrate – the current state of research and debate in the discipline. They tend to carve out particular areas for themselves, whether by method and approach or by subject area. There are more Art History related journals published in the English language than in any other European language, though this is not to say that there are not important publications in French, German, Dutch, Italian, and so on. I shall address only the English-language journals here. Already some journals are available 'on line' and, at the time of writing, a vigorous debate is underway about the future of journals in hard copy. It seems, however, unlikely that journals in the Humanities will go over entirely to electronic form.

The best place to read journals is on the current-journals stand in your institutional library, bearing in mind that virtually all libraries in the UK have had to cut their journals budgets over the past few years and that the range of subscriptions will vary from one institution to another, normally reflecting the needs of undergraduate teaching and research. Inter-library loan arrangements will usually compensate for the deficit of particular numbers of a journal. Reading the same journal each month or each quarter enables you to become familiar with editorial policy and to have the chance of following an ongoing debate through successive issues. Browsing

through a range of recent and current journals is *the* best way of getting an idea of the range of interests in the discipline and the current concerns of scholars.

It would be very difficult adequately to classify the journals in Art History, and it should be noted that many journals that do not specifically address the visual arts carry articles from time to time that may be of great importance to art historians. Among them would be *Victorian Studies* and *Past and Present* (history journals), *New Formations* (sociology), *Feminist Review*, *Genders* and *Renaissance Studies* (literature, history and cultural studies), *Screen* (film studies), the *British Journal of Aesthetics* (philosophy), and the *Journal of Design History*. If you are interested in art world current affairs, try *The Art Newspaper* (sale-room news, book reviews and international art gossip).

If we consider journals that specialize in visual communication we might usefully isolate the glossy, large-format international magazines which carry substantial amounts of advertising for the art trade and specialize in high-quality reproduction. Best known is *Apollo*. Distinguishable from these are those journals (not necessarily with a smaller circulation) which carry less advertising and which are informed by an editorial policy more attuned to debate and analysis and less concerned with attribution and classification. Many of these are edited from within institutional Art History departments, some by individuals and others by collectives. They would include: *Art History** and the *Oxford Art Journal* (leaders in the UK), *The Art Bulletin*, *Art Monthly*, *October** and *Representations** (published in the USA, the last two being much concerned with literary theory as well as visual communication). Concentrating on particular aspects of visual and material culture are the *Architectural Review**, the *RIBA Journal**, *Word and Image*, the *Journal of Garden History*, *History of Photography*, the *Journal of Art and Design Education*, *Modern Painters*, *Asian Art and Culture*, the *International Journal of Cultural Property*, *Design Issues* and many others. A more traditionally orientated scholarly journal with a long and distinguished history is the *Burlington Magazine.**

Some of the journals named above are organs of particular professional associations (*Art History* is the journal of the British Association of Art Historians; *Art Bulletin* and *Art Monthly* are published under the aegis of the College Art Association of America). Both organizations welcome student members and organize a range of conferences and other events. Alongside these publications are journals that are published annually, like the *Journal of the Warburg*

and Courtauld Institutes and *The Walpole Society*, and the proceedings of dozens of archaeological societies of different regions of the British Isles. Appropriately we should conclude by mentioning a few of the exciting journals and magazines that specialize in contemporary art practice, probably best located (if your institution does not have studio-based work) in the Tate Gallery bookshop in London or in Liverpool. *Contemporary Art, Artforum* and *Arts Review* are three such magazines. All the journals mentioned in this section and marked with an * offer discounts to students.

Index